PENGUIN BOOKS

Ornament and Crime

ADOLF LOOS was born in Brno in 1870 and died in Vienna in 1930, living through and shaping the great period of Viennese art and design which substantially ended with the disaster of the Great War and the collapse of the Habsburg Empire. His major works include the interior of the Café Museum (1899, recreated 2003), the American Bar (1908), the revolutionary Loos House and Steiner House (both 1910), all in Vienna; and the Villa Müller (1930) in Prague.

A central figure in the capital's cultural life, Loos was friends with figures as varied as Arnold Schönberg, Ludwig Wittgenstein and Karl Kraus.

His lectures and essays have been enormously influential statements on aesthetics, insisting on a combination of stripped-down simplicity in architectural design and the use of rich and beautiful materials in ways true to their real form. His essays also preserve his caustic, witty personality.

SHAUN WHITESIDE is a distinguished translator of both German and French literature. His translations for Penguin include Sigmund Freud's *On Murder, Mourning and*

Melancholia, Norman Ohler's *Blitzed*, Friedrich Nietzsche's *The Birth of Tragedy*, Sybille Steinbacher's *Auschwitz* and several novels by Georges Simenon, including *Maigret's Doubts* and *The Saint-Fiacre Affair*.

JOSEPH MASHECK, modern art and architectural historian and critic, and sometime editor-in-chief of Artforum, was awarded the 2018 Distinguished Lifetime Achievement Award for Writing on Art of the College Art Association.

ADOLF LOOS

Ornament and Crime

Thoughts on Design and Materials

Translated by Shaun Whiteside

PENGUIN BOOKS

PENGUIN CLASSICS

UK | USA | Canada | Ireland | Australia
India | New Zealand | South Africa

Penguin Books is part of the Penguin Random House group of companies
whose addresses can be found at global.penguinrandomhouse.com.

This collection first published in Penguin Classics 2019
001

Set in 12/16.5 pt Haarlemmer MT Pro
Typeset by Jouve (UK), Milton Keynes
Printed and bound in Great Britain by Clays Ltd, Elcograf S.p.A.

A CIP catalogue record for this book is available from the British Library

ISBN: 978-0-141-39297-4

www.greenpenguin.co.uk

CONTENTS

OUR SCHOOL OF APPLIED ART (1897)

The school of the Austrian Museum, our School of Applied Art, has been showing the achievements of the last school year since the 9th of this month. Again we see the usual works, executed with the usual precision, to familiar acclaim in the daily newspapers. And indeed, when we stand in Ferstel's solid Italian rooms and consider the still-lifes, the flower paintings, nudes, pictures of the saints, scenes in the style of Tadema, portraits, statues, reliefs, woodcuts, drawings for furniture publications, etc., etc., even the harshest critic among us would be forced to conclude: much has been achieved here. In the school on the Stubenring, painting, sculpture and the graphic arts have something like a secondary Academy. Our Art College on Schillerplatz has a competitor, and even if the accomplishments of that institution cannot be surpassed, because the

3

period of study is too short, this worthy competition has beneficial results. Thus Schillerplatz gets a sharp reminder that it needs to rouse itself from its state of stagnation, and Stubenring turns out second-rate artists. So, one might think, no one should object. That is wrong. Because this race is being run at the expense of something else. And that is applied art, craft.

Let us say it straight out: because of this way of behaving, the applied arts are being actually betrayed. The small sum which, according to the budget for the Ministry of Education, is allocated to education in the applied arts is entirely inadequate for its purpose. We Austrians, who in this regard should be penny-pinchingly frugal because of the inadequate funds, are letting our arts and crafts starve and die at the cost of 'great art'.

This injustice has been committed over the centuries with no one to advocate for our betrayed crafts. For our craftsmen the secret has long been in the open: the workers emerging from this institution are useless for the workshop, for life, for the public. Stuffed full of wrong ideas, without knowledge of material, with a fine sense of imminent nobility, without

4

knowledge of contemporary trends, they either add to the large number of minor painters and sculptors or go abroad to make up for the short-comings of our own education, if the possibility of assimilation exists. But then they are lost to us. We ourselves cannot take them into the school, we are not strong enough. On the contrary: we expect this institution to provide a stimulus that should set us in motion.

Because we have stagnated for a long time and we are stagnating still. Over the last decade the whole world of the applied arts has taken great strides under England's leadership. The distance between us and everyone else is becoming ever greater, and it is high time that we took care not to miss our connection. Even Germany has been catching up at a gallop and will soon be joining the victory procession. Such new life abroad! The painters, the sculptors, the architects are leaving their comfortable studios, hanging 'high art' on the peg and taking their place by the anvil, the loom, the potter's wheel, the kiln and the carpenter's bench! Away with all drawing, away with all paper-based art! What we need to do now is to wrest new forms and

lines from life, habits, comfort and utility! Get to it, journeymen, art is something that must be overcome!

In view of this constantly growing enthusiasm for the arts and crafts movement we must deeply regret the fact that our artistic youth stands coldly and apathetically aside. Even those with a calling for it flirt with the fine arts, as we have seen. The reverse, artists returning to craft, is of course not taking place. Is there really so little propensity for enthusiasm among your young people?

But the few works in the exhibition which refer to applied art can already give us an answer to this question. It is as if the pupil's own soul were being drawn, corrected, built, modelled and taught out of his body and replaced by a rigid dogma. Nature is studied – but without success. Because for the applied arts this study is only a means to an end. But the end that is to be reached is that of stylizing what is present in nature, or rather making it useful to the material from which it is to be formed. But the school lacks the courage and strength as well as the knowledge of material. But the dogma that will

inevitably destroy this school is the view that our arts and crafts should be reformed from the top down, from the studio. But revolutions always come from below. And that 'below' is the workshop.

The view still prevails here that the design of a chair should only be entrusted to someone who knows the five orders of columns off by heart. Such a man, I think, would primarily be bound to know something about sitting. But so be it: if it does no good it does no harm either. But no advantage will come from a chair composed in the wrong order of columns. Here I am referring to the entasis of a Doric order, which is constructed like a Roman column. That is a real slap in the face for the Doric spirit. But let us go further than that. The furniture designers who achieve outstanding work as designers of advertisements, a skill that must surely fall within the sphere of graphic art, fail entirely where their own designs are concerned. Ignorance of materials when it comes to copying details from nature – we need only consider mouldings that run counter to the techniques of cabinet-making – and dull copying, what experts call plagiarism, in the

drawings for the decorations of internal spaces are the common features of all three specialist studios in our school. It is not the teacher who should be considered at fault here: it is the spirit that hovers over the whole institution.

We can't help repeating what we have said already. There is proficient work here too, as long as we only address the subject of painting. When it comes to the applied arts, the best drawings fizzle out. Naturalistically drawn pumpkins, to take one example – cleanly and very vividly shaded – do not do the job, particularly when they are conceived as a wallpaper frieze just below the ceiling; one would not be overly keen to venture into such an unfortunate room for fear that they might fall on one's head. It is proficient drawing that guarantees the perpetuation of this illusion . . .

We might continue in this way, sheet after sheet, but this one example will probably bear sufficient witness to the thoughtlessness that sees no further than the end of the drawing-board.

We may cling to the hope that this will have been the last exhibition of its kind. At last unto craft will have been rendered the things that are

craft's. With the new director, Privy Councillor Arthur von Scala,[1] a new spirit has entered the building. May this spirit be strong and reckless enough to be master of the house towards the old. Austrian craft expects no less.

CHRISTMAS EXHIBITION IN THE AUSTRIAN MUSEUM (1897)

(Bourgeois Household Effects – the Lefler room)

It cannot be denied: the collection of copies of old furniture now on show in the Austrian Museum has caused a sensation. It is the talk of the town. One feels transported back to the best days of Austrian arts and crafts. Back in the day when Vienna was still a frontrunner in applied art, when the unforgotten Eitelberger[2] led the cohorts of the Stubenring, the public's interest in decorative art can hardly have been greater. Again we read reports in the daily newspapers about new paths and trends; people debate, people argue. More than that, in fact: they revisit the Christmas exhibition.

What has actually happened? A new director has been appointed at the Austrian Museum, and this new director has opened up a new area for us. He has granted access to the modern style, some say. He has introduced Anglicism, say others. He

stresses the practical aspect of everyday objects, say yet others. Who is right? All of them, in fact. But they haven't found the right term. He has, I would say, discovered bourgeois household effects.

I know this explanation will provoke a general puzzlement. Have we not collected the best objects of all times, whichever social class they might have belonged to, conserved them in the museum and studied them? Have we not copied the best bourgeois pieces of gothic, the Renaissance, the Baroque, the Rococo and Empire? Have we not always furnished our homes in the bourgeois style?

No, we haven't. Our wives and daughters sleep in a bed in which even Marie Antoinette, the unfortunate daughter of the Emperor, would have dreamed in the Trianon of glory, happiness and splendour. Mr Master-Butcher looks with pride at an old German sofa, whose patterns are borrowed from the wall panelling of the state room in the Town Hall in Bremen and combine part of it – all of it would be far too expensive – with an upholstered chest. And in the drawing room of an affluent stockbroker the guests

stretch out in armchairs exactly like the one from which Napoleon once imposed his law on the world. Even the imperial 'N' is obligatory. And yet the Corsican only used this throne once. Otherwise he and his guests would have settled for less ambitious furniture.

But why do we know so little about middle-class household effects? Because a disproportionately small amount has come down to us. Because the middle class used their furniture up, they used it every day, and in the end they heated the house with it. They couldn't afford magnificent, showy rooms. And if one piece of furniture or other survived, it was almost impossible to find a museum to give shelter to the old household pet. It was distinguished neither by elaborate work nor by noble materials. And if it had won for itself a modest little place in a collection here or there, it was probably ignored. Quite the contrary with princely furniture. It was never used, or rarely, and showed its elegant, do-nothing character by displaying motifs of high architecture, and by being richly decorated. But if it was unsuitable for practical use, it was not pointless in its own circle. Its purpose was to represent and

bear witness to its owner's wealth, splendour, love of art and sheer good taste. Princely furniture was consequently, and rightly, preserved, and forms the pride and joy of every museum.

Our century has made bad use of these exhibits by taking them as a practical model. The barriers that royalty had erected against the nobility, the nobility against the lower aristocracy and the lower aristocracy against the middle class, had fallen, and anyone could furnish his house and dress according to his taste. So we can actually hardly be surprised if every manservant wants furniture that could easily have graced a royal court and every cellarman wants to dress like the Prince of Wales. But it would be wrong to see this situation as progress. Because princely furniture, the product of vast superfluity, costs huge sums of money. But as the general public do not have access to such wealth, they copy the forms at the expense of material and execution, and half-measure, hollowness and that terrible monster that threatens to suck all the marrow from our bones, imitation, make their entrance.

And the life we lead also contradicts the

objects with which we surround ourselves. We forget that as well as the throne room we need a living room. We allow ourselves to be abused by our stylistic furniture. We bump our knees black and blue on them, and imprint whole ornaments on our backs and bottoms by the very act of sitting down. Over the last few years we have given ourselves two decades' worth of Renaissance, Baroque and Rococo blisters, one after the other, from the variously ornamented handles of our drinking vessels. But we didn't complain, because those who resisted such things would have been pilloried as ignoramuses, as people without a higher understanding of art.

But what I am suggesting here applies only to the Continent. Across the Channel there lives a nation of free citizens who have weaned themselves off the old divisions for so long that parvenu transformations have no place there. These people have abandoned princely magnificence and princely grandeur in their homes. They gave up on dress codes a long time ago, and consequently take no special satisfaction in aping the great men. Their own comfort is more important to them than anything. And under the influence

of their middle class even the aristocracy in that country is slowly going through a transformation. They have become simple and plain.

A country that has such a confident, free middle class must soon inevitably the middle-class domestic style to its fullest flower. Here, the best craftsmen can work for them, they are able to concentrate on these tasks, while in other countries princely furniture would be entrusted to a master of the first rank, and middle-class household effects would be made by the second-rate. We need only consider the two most significant designers in England and France from the same period. Let us take, for example, Thomas Chippendale and Meissonier, the designer of Louis XV. Meissonier's work consists entirely of designs for the king's state rooms and halls, while Chippendale is best summed up by the unassuming title of a collection of his copperplates: *The Gentleman and Cabinet-maker's Director, being a Collection of Designs of Household Furniture.*

One will therefore understand that in any collection of bourgeois furniture the lion's share will be the English. After all, they have even given

a home to a certain amount of *German* bourgeois furniture that has been forgotten here in the meantime, and which is now on its way back to us via England. There are interesting examples of this; let us mention one of them here. The bright-red painted chair with yellow wicker that strikes us today as so terribly English (we mockingly call them *Sprösselstühle* or chicken-perches) appears in many eighteenth-century German paintings of interiors, especially in the work of Chodowiecki.

One other circumstance helps to explain the large number of English designs. England was the first country to go into battle against imitation. Now we too are slowly beginning to wage war against it. Fake gemstones and fake furs are already no longer, thank heavens, considered elegant, even here. We must thank our Christmas Exhibition for inspiring us to apply the new theory to domestic furniture as well. Anyone who lacks the money for a pressed-leather chair can simply buy a wicker one. Some people will be horrified. A straw-bottomed chair, how vulgar! Go to it, my dear Viennese, a straw-bottomed chair is no more vulgar than going out without diamonds, or wearing a simple cloth collar with

one's winter coat. But imitation diamonds, fur collars and leather chairs – they are truly vulgar.

And so it is slowly dawning on us that if there is not enough money for opulent and decorative objects, the main focus must be on the solid and the practical. Painted inlays, wood-carvings made of sawdust and glue, 'botch-it-yourself' windows and other patents from the armoury of imitation, the doors and windows painted like hard wood, are slowly disappearing from the bourgeois house. Middle-class pride has awoken, the attitude of the parvenu is slowly falling out of fashion.

But the key to the exhibition is an interior created collaboratively by some Viennese: the painter Heinrich Lefler, the sculptor Hans Rathausky and the architects Franz Schönthaler Junior and Josef Urban. In everyday conversation it is referred to as the Lefler room. That shorthand was absolutely necessary, because for the last few weeks it has been on everyone's lips. Praised to the skies by the young, deeply reviled by the old, this room is seen as the first thrust of the modern in decorative and applied art on Viennese soil.

This room does look modern. But if one

examines it more closely, it is only our good old German Renaissance costume-ball room recast in a modern light. Nothing is missing: the wood panelling with the stencilled-on wooden inlays, the old German decorative sofa (God rest its soul), from which the nailed-on brass lions' heads, the ones that held the Persian throw in place, were always being pulled off, and with the shelf above on which wine glasses and decorative beer mugs wobbled around so nicely when one made the slightest movement – all of these were carried over along with the rest, and masked themselves so beautifully that you do not recognize them at first. While, for example, with the old 'decorative sofa' a beer mug could fall on your head at any moment, it is now an English vase, but it is bound to do so. A great advance in that half-measures are now avoided, and one that can only step up porcelain consumption.

So we can see already what this room is getting at. It is bringing us modern forms in the old spirit. So we have no right to speak of a modern room. They would have been doing modern art a big favour if they had used old forms in a new spirit.

Let us turn our attention to the individual

works. Lefler has provided delightful wallpaper, by far the best in the room. Our Austrian wallpaper industry has nothing of the kind to set beside it. Just imagine: modern wallpaper that has nothing English about it, and whose Viennese origins are visible at first glance. The appliqué cushions and the carpets are also first-rate. The mohair rug Dragon Battle also displays a proficient command of technique. But Lefler's technique faltered when it came to the design of the stained-glass windows. He provided two: one is called Cinderella, the other Sleeping Beauty. Both reveal an oscillation between two techniques, stained-glass and American work on glass melts. Cinderella has a harmonious appearance, since here stained glass was used only when it was absolutely necessary, for example on the faces. But Sleeping Beauty is unforgivable. The painted rose hedge is a slap in the face for honest glasswork. With what joy would a glass technician have seized the opportunity to show his art in the roses. Every rose petal a different glass melt! These roses cry out for American technology, all the more so in that it is used in passing at a few important points. And that is why this window looks so

unharmonious. The attempt to leave the middle window free to allow an unobstructed view outside seems to me to be worthy of imitation. All in all Lefler's works show a fresh willingness to take the bull by the horns, and a resolute talent for subjecting himself to new techniques.

The same cannot be said of the other works. The imitated inlays in the wall panelling and the banal papering of the ceiling suggest a lack of elegance. A splendid trousseau is spoiled with artificially patinated bronze reliefs which, if they were real, would not say much about their owner's cleanliness. We should bear in mind that the green patina on the bronze objects has formed through their lying for thousands of years in damp earth, but that it would be completely absent if the objects were still in use. We could, however, still expect our moderns to reject this archaizing hoax. I have already mentioned the shelf that crowned the lightly carved sofa. And then there is clock from which one cannot tell the time. That used to be so because the face was 'stylish'; now it is because it is square.

It would therefore be unfair to make modern interior decoration responsible for this room.

The modern spirit demands above all that an everyday object be practical. For this spirit beauty is the supreme perfection. And since the unpractical is never perfect, it is also impossible for it to be beautiful. Secondly, it requires unconditional truth. I said above that imitation, pseudo-elegance, is, thank God, at last becoming unmodern. And thirdly it demands individuality. That is to say that in general the king should furnish his rooms like a king, the middle classes like the middle classes and peasants like peasants, and that most particularly every king, every middle-class person and every peasant should express his own characteristics in the furnishing of his room. It is the task of modern artists to raise the taste of the masses by fulfilling the needs of the most intellectually elegant in each of its distinctive classes. Have our four artists done that? Does their boudoir correspond to the elegance of the aristocratic lady? No. And not the elegance of the manufacturer's wife either, and certainly not the elegance of the middle-class woman. Instead it seems that in this cheap elegance the old taste of the parvenu has bestirred itself once more. Hopefully for the last time.

GENTLEMEN'S FASHION (1898)

Being well dressed: who wouldn't want that? Our century has swept away dress codes, and everyone now has the right to dress like the king. We may use as a yardstick for the culture of a state the question of how many of its inhabitants make use of this achievement of liberty. In England and America everyone, in the Balkan countries only the top ten thousand. And in Austria? I wouldn't dare to answer the question.

An American philosopher says somewhere: a young man is rich if he has intelligence in his head and a good suit in his wardrobe. The man is well informed. He knows his people. What use is all one's intelligence, if one cannot show it off with clothes? Because the English and the Americans demand that everyone be dressed well.

But the Germans do something else besides. They too want to be well dressed. If the English

wear their trousers loose, they immediately inform them – I don't know whether with the help of Vischer or the golden section – that this is unaesthetic, and only tight trousers can lay claim to beauty. Blustering, swearing and cursing, they let their trousers get looser year by year. But fashion is a tyrant, people will then claim. But what is that? Has a revaluation of values taken place? The English are wearing their trousers tight again, and precisely the same arguments are deployed concerning the beauty of trousers, except in the other direction. It makes no sense.

But the English laugh at the Germans, with their thirst for beauty. The Medici Venus, the Pantheon, a painting by Botticelli, a song by Burns, yes, those things are *beautiful*! But a pair of trousers? Or whether a jacket has three buttons or four? Or whether the waistcoat is cut high or low? I don't know, I always get scared when I hear people discuss the beauty of such things. I get nervous when I am asked gloatingly about a piece of clothing: 'Might that be *beautiful*?'

The Germans from best society are a match for the English. They are pleased when they are well dressed. Beauty has nothing to do with it.

The great poets, the great painter, the great architect dress like them. But the little poets, painters and architects turn their bodies into an altar on which beauty in the form of velvet collars, aesthetic trouser materials and Secessionist ties is to be sacrificed.

What does it mean to be well dressed? It means to be correctly dressed.

Correctly dressed! It is as if with these words I had revealed the secret with which our fashion in clothing had hitherto been surrounded. People hoped to get to fashion with words like beautiful, chic, elegant, smart and dashing. But that isn't what matters at all. What matters is to dress so that one stands out as little as possible. A red tailcoat stands out in the ballroom. Consequently the red tailcoat in the ballroom is unmodern. A top hat stands out when one is ice-skating. Consequently it is unmodern on the ice. In high society anything conspicuous is considered inelegant.

But this principle cannot be enforced everywhere. With a coat that went unnoticed in Hyde Park, one might very well stand out in Peking, in Zanzibar or in St Stephen's Square. It is European.

But we cannot demand that anyone who is at the height of culture should dress in the Chinese style in Peking, the East African style in Zanzibar and the Viennese style in St Stephen's Square!

The principle thus receives a qualification. To be correctly dressed, one cannot stand out at the centre of culture. The centre of western civilization is currently London. But what are things like there? London is very big, and if one were to take a stroll one might find oneself in areas where one stood out very much in one's surroundings. So one would have to change one's coat from one street to the next. That is impossible. But now we have exhausted all eventualities, and we can give a complete formulation to our theorem. It reads: a piece of clothing is modern if one stands out as little as possible in it at the cultural centre on a particular occasion in the *best* society. But in the German middle and lower classes this English point of view, with which any elegant-thinking person would have to concur, encounters vigorous opposition. No nation has so many fops as Germany. A fop is a person who uses clothes only to stand out against his surroundings. Now ethics, now hygiene, now aesthetics are adduced

to help explain this clownish behaviour. A common thread leads from Meister Diefenbach[3] to Professor Jäger, from the 'modern' minor poet to the Viennese son of the grand house, linking them all together intellectually. And still they cannot bear one another. No fop can admit to being one. One fop makes fun of the other, and on the pretext of eradicating fophood, they constantly commit new acts of foppery. The modern fop, or the fop as such, is only one species from this broad family.

The Germans suspect this fop of setting the tone for gentlemen's fashion. That is an honour that these harmless creatures do not deserve. From what I have said above it is clear already that the fop does not even dress in a modern way. But neither would that serve him well. The fop wears precisely what those around him *think* is modern.

Yes, does that not mean it is the same as modern? By no means. Hence fops in every city are different. What impresses in A has already lost its charm in B. Anyone who is still admired in Berlin runs the risk of mockery in Vienna. But the elegant circles who find it too petty to worry

about such things will always privilege those changes in fashion that most escape the notice of the middle classes. They are no longer protected by dress codes, and it is not agreeable to them to be copied by everyone the very next day. Then, however, one would immediately look around for a substitute. To escape this eternal hunt for new fabrics and cuts, resort is made to the most discreet devices. For years the new form is carefully protected like an open secret belonging to the great tailors, until at last the beans are spilled by a fashion magazine. Then it takes a few years before the last man in the country becomes aware of them. And only now is it the turn of the fop to take charge of the matter. But on its long journey the original form has changed a great deal and also been subordinated to its geographical situation.

One can count on the fingers of one's hand the great tailors throughout the world capable of attracting anyone according to the most elegant principles. There are Old World cities with a population of a million that cannot claim such a business. Even in Berlin there was none until a Viennese master-tailor, E. Ebenstein, set up a

branch there. Before Ebenstein the Berlin court was forced to have much of its wardrobe made by Poole in London. That we have some of these names in Vienna is only down to the fortunate circumstance that our aristocracy is a constant guest in the Queen's drawing room, has been sent to work in England a great deal and in this way transposed that elegant tone in clothing to Vienna, which took Viennese tailoring to a peak that is envied abroad. It can probably be said that the top ten thousand in Vienna are the best dressed on the Continent, because these great firms also brought the other tailors to a higher level.

The great firms and their immediate descendants all have one feature in common: fear of the public. Where possible they limit themselves to a small clientele. They are probably not as exclusive as some London houses, which open only on a recommendation from Edward, the Prince of Wales. But all outward pomp is alien to them. It was a great effort for the directors of the exhibition to move some of the best in Vienna to exhibit their products. One must acknowledge that they escaped the noose very skilfully. The only objects exhibited were those that could not

be copied. The most skilful of all, perhaps, was Ebenstein. He is showing a *demi-dress* (here wrongly called a 'smoking jacket') for the Tropics (!), a *hunting vest*, a Prussian regiment member's lady's uniform and a 'coaching coat' with engraved mother-of-pearl buttons each one of which is a work of art. A. Keller is showing a tailcoat with the obligatory grey trousers in which one could calmly travel to England, alongside elegant uniforms. The Norfolk jacket also seems to be well made. Uzel & Son are showing the speciality of their workshop: court and state uniforms. They must be good, or else the company could not have maintained its status in this field for so long. Franz Bubacek has exhibited the Emperor's sports clothes. The cut of the Norfolk jacket is new and correct. Herr Bubacek is showing great courage in this exhibition, and does not fear imitation. The same may also be said of the hunting clothes of Goldman & Salatsch, who are also showing their speciality, the uniforms of the yacht fleet. Joseph Scalley is showing a rich collection of uniforms with his company's well-known precision. Emerich Schönbrunn perhaps forms a transition. Some

pieces probably prove that their maker is capable of working elegantly, but they also display an inclination to make concessions to other circles.

But that brings my unconditional praise to an end. The collective exhibition of the Guild of Viennese Clothes-Makers does not deserve it. Sometimes when working for clients one must close both eyes, since the customer, by stressing his own desires, often holds sole responsibility for her own lack of taste. But here the craftspeople could have shown that they could probably compete with the big companies if they were given free rein. But most of them have missed this opportunity. Even in the choice of their material they reveal their ignorance. From *covert coat* material they make greatcoats, and from greatcoat material *covert coats*. From *Norfolk* material they make sports suits, from smooth cloth frock coats.

The cuts are no better. Few are approached from the perspective of working elegantly; most tailors have addressed themselves to fops. And they can revel in double-breasted waistcoats, checked suits and velvet jackets. One firm even puts blue velvet cuffs on the sleeves of a jacket! Now if *that* isn't modern . . .

Here I will name some who have to some extent kept themselves out of this witches' Sabbath. Anton Adam is good, but he cuts his waistcoats too low, Alois Decker also deserves a mention, Alexander Deutsch has a good winter greatcoat, Joseph Hummel a good *Ulster* and *Norfolk*, P. Kroupa sadly vandalizes an otherwise correct frock coat with a border, Emanuel Kühl is elegant, so is Leopold Kurzweil, Johann Neidl and Wenzel Slaby each have a proper frock-coat suit. Joseph Rosswall shows a good tailcoat. I would have liked to name another firm openly exhibiting its products. But when I tried to lift the flap of the *Norfolk jacket*, which is designed to allow freedom of movement to the arm with folded fabric, I could not. It was fake.

GENTLEMEN'S HATS (1898)

How is fashion made? *Who* makes fashion? These are certainly very difficult problems.

The Vienna Fashion Hat Association had the opportunity to provide a playful answer to this question, at least in the field of headgear. Twice a year, in fact, they sit around the green table and dictate to the entire globe the form of hat that is to be worn the following season. The whole globe, let us not forget. They are not making Viennese folk costumes that our stablemen, coachmen, spivs, fops and other Viennese local types might wear. Oh no, the members of the Fashion Hat Association would not stretch their minds for these people. The fashion in hats is meant only for the gentleman, and since as we know the clothing of such an individual has nothing in common with the various national costumes, except when practising country sports, since gentlemen all

over the world wear the same thing, the Vienna Fashion Hat Association sets the tone for all headgear in western culture.

Who would have thought the solution of this question would be so simple! It is with respect that I now consider the honourable master hatmaker, who has raised his voice in favour of the repeated elevation of the silk hat and in this way, with a one-vote majority, enforced this regulation. He alone has forced flâneurs from Paris to Yokohama to don an even taller silk hat next year, if they wish to be considered a part of good society. But what do the flâneurs from Paris to Yokohama know? What do they know of the fine master in the eleventh district? They may perhaps maunder on about the tyranny of fashion, or at best about fashion, that capricious goddess! If they had any idea! The fine master in the eleventh district is the tyrant, the god!

We cannot imagine what the consequences might be if this man were prevented from appearing in the choice of fashionable headgear. Whether by a cold, whether because his strict other half refused to give him the evening off, whether he had completely forgotten. Then the whole world

would have to wear a lower top hat. But it remains to be hoped that, given such colossal responsibility towards the world, nothing will keep the members of the Fashion Hat Association from casting their vote twice a year.

I think I hear my readers asking the question: so do the hat-makers of Paris, London, New York and Bombay allow the fashion in hats to be determined by the masters of Vienna? In a sheepish voice I must reply: sadly not. These bad people, with perfidious Albion, of course, at their head, are not concerned in the slightest about the results of these votes. So in that case are these votes entirely pointless? Actually – yes. They are a harmless piece of play-acting, just as innocuous as if the hatters of Bucharest or Chicago were doing the same thing. The shape of the hat of an elegant man who wants to be considered elegant anywhere around the world is not affected by it one whit.

But wait: this play-acting is not so innocuous at all. There are in fact more elegant people than our hatters commonly assume. And since they are unwilling to wear hats whose elegance stops at the black and yellow border posts, but

our hatters make them at the bidding of the Fashion Hat Association, they are forced to acquire English hats. And we see how the use of English hats in Austria, even though they are 100 per cent more expensive and the same quality, increases to the same degree from year to year the further removed the models of the Fashion Hat Association are from the members of fine society. This becomes even sadder when we bear in mind that, with our excellent felt and our low prices, we could easily compete with the whole world. The promulgation of the Viennese hat abroad has always been defeated by incorrect form and execution.

Among their customers in the most elegant circles of society, our leading firms have had their worst experiences with the styles of the Fashion Hat Association, and have soon abandoned their allegiance to the association. At Pless or Habig one will seek these styles in vain. And the emancipation has soon made itself apparent in terms of exports too. Habig hats can now be found all over the world, from New York to Rio de Janeiro. But I fail to see why the court hat-maker, who is quite able to obtain the right models thanks

to his connections abroad and his fashionable clientele, should stock different hats from the provincial hat-maker.

Rather than presenting as modern a hat that has sprung from the imagination of one of its members, the Fashion Hat Association would need only to promote the shape that is considered modern all over the world and in the most elegant circles. That would lead to a rise in exports and a decline in imports. In the end it would be no bad thing if everyone, even in the smallest provincial town, wore just as elegant a hat as the Viennese aristocrat does. The time of dress codes is over, after all. But some decisions made by this Association have caused actual damage to our hat industry. And the consequences of that? The crown of the top hat is now slightly lower than last season. But for the top hat of the coming winter, the Association *decided* that it should be higher again. The English hatters are already preparing an extraordinary mass export of silk hats to the Austrian market, since the modern top hat will not be available from every Viennese hat-maker next winter.

There are other respects in which the

Association's activity might prove to be a blessing. Our Austrian national hat, the Loden hat, is just beginning to make its way around the globe. It has already reached England. The Prince of Wales encountered it and came to appreciate it on his hunting expeditions in Austria and brought it back home with him, where it has now conquered English society, both gentlemen and ladies. Truly a delicate moment, particularly for the Loden hat industry. We might in fact wonder who will make the Loden hats for English society. The Austrians, surely, while they still produce the forms that English society wants. This, however, requires boundless sensitivity, a precise knowledge of society, a sense of taste and a good nose for future developments. Styles cannot be forced upon such circles by a simple majority vote around the green table. The large manufacturer is very well aware of this, but I think that the small hatters should become involved when the time is right for their product. The Fashion Hat Association, if it feels capable of dealing with this difficult question, should take matters in hand on their behalf. But perhaps even the large manufacturers are not

aware of this either. Then the English will be the happy heirs to the great treasure that the small hat-maker in the Alps has carefully guarded for a thousand years.

In fact the English conduct business quite differently from the Austrians. Different hats are made for different markets. Let us not be deceived: the English hat that we see on the Viennese market is a compromise between the modern hat and the Fashion Hat Association's hat. Even for savage peoples they manufacture objects that most appeal to them. The English treat us as they do savages. And they are quite right to do so. In this way they sell us a great many hats, while with the hat worn in the best society, which is to say the modern hat, they would do very little business. They do not sell the Viennese the hat that is modern, but the one that the Viennese *consider* to be modern. And there is a big difference between the two.

The correct ones are sold only in London. When I ran out of London hats, I went in search of the *correct shape* here. Then I found that the English hats sold here did not correspond to the ones in London. I commissioned a hat-maker to

order me a hat from London in a style also worn by the members of the Royal Family. I made the guarantee of the London house a condition. The cost was irrelevant. It got me nowhere. After months of excuses, after a considerable sum had been telegraphed, the British company broke off negotiations once and for all. But it would be easy for the Fashion Hat Association to make these styles. Speed was not an issue either. We should be very content to obtain a hat today that the English were wearing three years ago. That would be such a hyper-modern hat for us that no one in Vienna would notice. And that is what one can demand of a modern hat. Fashion moves slowly, more slowly than is usually assumed. Objects that are truly modern remain so for a long time. But if one hears of an item of clothing becoming unmodern in the next season, if in other words it was considered unpleasing, then one may claim that it was never modern, but incorrectly presented itself as such.

Looking at our hat-makers' exhibition in the Rotunda, it is heartbreaking to consider that such a prestigious industry is no longer involved in the export trade. There is nothing tasteless

here apart from the portrait of our Emperor in the hat-lining, and even the smallest hat-makers are capable of manufacturing hats of a quality just as excellent as those of the leading houses. How high the standards are – and sadly the same cannot be said of other areas of the clothing industry. Each one seeks to make an impression through his essential competence, and the familiar exhibition tricks of attracting the viewer's attention through adventurous forms are entirely reviled. As a result this whole part of the exhibition is attuned to a fine and elegant tone. In a single vitrine the Hat Makers' Association brings together twelve exhibitors – small and large hat-makers, all of excellent quality. Our firms – Habig, Berger, Ita and Skrivan – are distinguished by the richness of their exhibits. Sadly I cannot judge the correctness of the styles, having been in Vienna for two years. But where elegant accoutrements are concerned, I should award the prize to Ita.

But we might wish that our Fashion Hat Association might attempt to join forces with the other civilized nations. The creation of an Austrian national fashion is a phantom whose

rigid grip would do inestimable damage to our industry. China is beginning to pull down its walls and is doing well out of it. We should not tolerate the erection of a Chinese wall in the name of fake local patriotism.

FOOTWEAR (1898)

'*Tempora mutantur, nos et mutamur in illis!*' Times change, and we change with them. And so do our feet. Now they are small, now big, now pointed, now wide. And shoemakers make now big, now small, now pointed, now wide shoes.

But things aren't as simple as that. The actual shapes of our feet do not change from season to season. For that to happen it takes centuries or at least a human lifetime. Because a big foot cannot become a small one in the blink of an eye. Other clothing designers are luckier in this respect. Full waist, thin waist, high shoulders, low shoulders, and so much besides, can soon be changed with a new cut, with padding and other devices. But the shoemaker must stick rigidly to the shape of the foot, whatever it may be. If he wants to introduce new shoes, he must wait until the large-footed race has died out.

But not all people have the same shape of feet at the same time. People who use their feet more will develop larger feet, and people who seldom use them will develop smaller ones. What is the shoemaker to do in that case? Whose foot shape should he take as standard? Because he too will inevitably be attempting to make modern shoes. He too wants to progress, he too is filled by the desire to give his creations as much purchasing power as possible.

So he does as all other craftsmen do. He sticks to the shape of the foot of those who happen to be socially dominant at the time. In the Middle Ages the knights were dominant, horse-riders who by virtue of spending much time sitting on horses had smaller feet than the ordinary footfolk. So the smaller foot was modern, and through elongation (long-toed shoes) the impression of narrowness, which was the aim, was further enhanced. But when the knighthood fell into decline, when the walking burgher of the cities attained the highest standing, the large, wide foot of the slow-walking patrician became the fashion. In the seventeenth and eighteenth centuries the more pronounced courtly life led

to the decline of pedestrianism once again, and through the frequent use of the litter the small foot (the small shoe) with a high heel, suited to park and palace but not to the street, came to prominence.

The revival of Teutonic civilization returned horse-riding to pre-eminence. Everyone who thought and felt in a modern fashion in the last century wore the English riding boot, even if they did not own a horse. The riding boot was the symbol of the free person, who had now finally overcome the economy of the buckled shoe, the air of the court, the gleaming parquet. The foot remained small but the high heel, which was of no use to the horseman, was abandoned. So the whole of the next century, our own, endeavoured to have as small a foot as possible.

But even in the course of this century the human foot began to undergo a transformation. Our social conditions have meant that we walk faster and faster from year to year. Saving time means saving money. The most elegant circles, people who had enough time, were caught up in this and quickened their pace. Today, a sprightly pedestrian takes for granted a gait hitherto used

by the footmen who ran ahead of carriages in the last century. Walking as slowly as people did in earlier times would be impossible for us today. We are too nervous for that. In the eighteenth century soldiers marched at a pace that would seem to us like standing alternately on one foot at a time, and which we would find very tiring. The increase in velocity is probably best illustrated by the fact that Frederick the Great's army took seventy steps a minute, while a modern army takes 120 steps. (Our drill regulations prescribe 115 to 117 steps a minute. But at present this pace can only be maintained with difficulty, as the soldiers speed up of their own accord. A new edition of the regulations will undoubtedly have to accommodate this feature of the age, certainly not to the detriment of the army's readiness to fight.) Accordingly, we can calculate how many steps our soldiers, and thus all people who wish to move forwards quickly, will march per minute in a hundred years' time.

Peoples with a more highly developed civilization walk faster than those who have remained behind, the Americans faster than the Italians. If you go to New York, you always have the feeling

that an accident has happened somewhere. On Kärntnerstrasse today, Viennese people from the last century would have the impression that something had occurred.

So we're walking more quickly. That means, in other words, that we push ourselves off the ground with our big toe more and more strongly. And in fact our big toe is becoming stronger and stronger and more and more powerful. Slow dawdling leads to a spreading of the foot, while quick walking, by more powerfully developing the main toe, leads to a lengthening of the foot. And since the other toes, particularly the small one, do not keep pace with this development, since they practically atrophy through low levels of use, this also leads to a narrowing of the foot.

The pedestrian has taken over from the horseman. The pedestrian is only an intensification of the Teutonic principle of civilization. Advancing by one's own strength is the slogan for the next century. The horse was the transition from the litter-carrier to the self. But our century tells the story of the fall of the horseman. It was the real century of the horse. The smell of the stable was our most elegant perfume, horse-racing our most

popular national game. The horseman was the spoilt favourite of folk song. Horseman's death, horseman's darling, horseman's farewell. The pedestrian was nothing. The whole world walked and dressed like a horseman. And if we wanted to dress nicely, we took the riding coat, the dress coat. Every student had his hack, the streets were alive with horsemen.

How different things are now! The horseman is the man of the plain, the flat land. It was the free English landed aristocrat who bred horses and appeared from time to time at the *meet* to jump over fences after the fox. And now he has made way for the man who lives in the mountains, whose joy consists in climbing mountains, who devotes his life to elevating himself by his own power above the human homesteads, the highlander, the Scotsman.

The horseman wears boots, long trousers that should be loose over the knee and very tight around the ankle (*riding breeches*). These are of no use to the pedestrian, the mountaineer. He wears – whether he lives in Scotland or the Alps – laced shoes, socks that must not reach over the knee, and bare knees. The Scotsman

also wears the familiar kilt, the Alp-dweller the Lederhosen – in essence the same thing. Even the fabrics are different. The man of the plain wears smooth fabrics, the man of the mountain rough weaves (*home spuns* and Loden.)

Mountain-climbing has become a need for human beings. The same humans who had such a violent horror of mountains even 100 years ago now flee from the plain to the mountains. Mountain-climbing, pushing one's own body higher and higher through one's own strength, is now seen as the noblest of passions.

Should that noble passion – and let us remember that even in the last century riding was described as a noble passion – exclude all those who do not live in the highlands? A means was sought to make it possible even for them, a contrivance was sought to execute that movement even on the plain: the bicycle was invented.

The cyclist is the mountain-climber of the plain. That is why he dresses as the mountain-climber does. He wears trousers that are loose at the knee, closing below it with turn-ups, so that the socks can be pulled up around them (they are turned over both in the Alps and in Scotland

so that they don't slip down). In this way the knee has enough play under the trouser to move without hindrance from the stretched to the bent leg position. In passing it should be mentioned that there are people in Vienna who do not know the significance of the turn-ups and who put the socks *under* the turn-ups. They make a similarly comical impression to the various Stritzows who paint the Alps red in the summer. But in terms of footwear the cyclist, like the mountaineer, wears lace-up shoes.

Lace-up shoes will dominate the next century as riding boots have dominated this one. The English have made the translation directly and still wear both forms today. But we have come up with a terrible hybrid for the transition period: the ankle-boot. The very unpleasant phenomenon of ankle-boots was made immediately plain to us when the short trouser arrived. Then it was obvious: without the benefit of concealment by the trousers, ankle-boots are unwearable. Our officers wore ankle-warmers to hide them and were rightly unhappy when the uniform regulation was applied more strictly, forbidding ankle-warmers among the infantry.

For us, however, ankle boots are dead, as dead as the tailcoat in daylight, whose comic effect only becomes apparent when we take it for a walk in the street. In the greatest heat we must put on an overcoat or sit in a coach. And look ridiculous: that has meant the death of every item of clothing in the past.

Because of pedestrian sport, the foot in our elegant circles is no longer as small as it once was. It is becoming increasingly larger. The large feet of Englishmen and Englishwomen no longer prompt our mockery as they once did. We too climb mountains, have bicycles and have – *horribile dictu* – ended up with English feet. But we console ourselves. The beauty of the small foot, particularly in men, is slowly beginning to fade. Recently a description of Rigo[4] reached me from America. One of his acquaintances does this in the following way: 'I knew the gypsy.' There follows a description that reads: 'A pair of revoltingly small feet peeped out from under the trousers.' Revoltingly small feet! That sounds convincing. The new doctrine comes from America! Holy Clauren,[5] if only you could have experienced this! You, whose heroes could never have sufficiently

small feet to be the fine figures of manhood dreamed of by a hundred thousand German maidens.

Tempora mutantur . . .

Here we should also mention the buttoned shoe, only acceptable in patent leather. They are shoes for doing nothing. Where smooth patent shoes, in dress uniforms, must be worn, in England and in Austrian aristocratic regiments, they are worn with polished leather uppers (under the trousers). But patent dancing shoes (pumps) are the only acceptable shoes for dancing.

I will talk about Viennese shoemakers and Viennese pedestrians next time.

THE NEW STYLE AND THE
BRONZE INDUSTRY (1898)

I am certainly sorry that I can't always give praise. Now and again I am obliged to deliver a word of blame. From the many letters that I receive, I see that this is resented in some quarters. The world of Viennese craft is plainly not used to serious criticism. Very much to its detriment. The many admiring articles with which exhibitions are so often greeted have, like the heat in a greenhouse, had a slackening effect on the craft, and there is a danger that the slightest draught might give the spoilt pet a cold. Were I equally convinced of this, I would not contribute to the gust of wind. But as it is, I think that the child of such healthy parents can easily cope with a bit of a draught. It will toughen him up.

Many of my thoughts will also cause consternation. I am looking at the exhibition not from a Viennese but from a foreign standpoint.

Deliberately. Because I am writing expressly with regard to the Paris exhibition. I want to draw the Viennese craftsmen's attention to those products that they take so much for granted that they don't consider them worth exhibiting, but which are considered unsurpassed in the rest of the world. But at the same time the Viennese should be warned against showing in Paris products that can be made better abroad.

Yes, do craftsmen themselves not know what they do best? Oh no. Just as little as poets, painters or artists of any kind know or can know. They will always place most value on the child of their Muse that has tormented them the most. But that which best corresponds to their nature, to their predisposition, what they have produced most effortlessly, what bears the mark of their individual, and hence the best, their very own, can never strike them as especially outstanding. Only the agreement of the public can teach them the correct judgement of their achievements. But the Viennese has heard the judgement of London, Paris and New York so seldom. And now the right moment seems to me to have come, after which, at the end of the century, we must subject ourselves to this judgement.

In Paris we should show people what we can do, not what we can't but would like to be able to. Exhibiting these things would be of little use to us. I would sooner see fewer ingenious objects than those that could be seen better, if only by a shade, in another category.

In Paris they are probably about to resolve, for the next few years, the most burning question that currently dominates our arts and crafts: the old styles or the modern style? Other civilized countries adopted a position on the matter long ago and will therefore also impress in Paris with their firm and resolute presence. Even the German Reich, whose entrance in Chicago was accompanied by the sound of trumpets, having noticed that this *grandezza* was inappropriate, modestly withdrew to learn something from the Americans; even the German Reich, then, which had lagged behind for so long, enthusiastically joined the other civilized nations. However, we have remained behind, we have remained so far behind that our craftsmen are defiantly spurning the saving hand that Privy Councillor von Scala offers them, and have even launched a newspaper of their own to combat the new trend. In Germany

over the past few months four newspapers have been founded to propagate this new tendency, and if anyone wanted to bring out a paper to counter it he would be welcomed with boundless joy. We are certainly no more stupid than anyone else out there. On the contrary! We even have something that most of them lack – our triumphant good Viennese taste, which many might envy us. The only people to blame are our unreasonable schools, which have inhibited the natural development of our arts and crafts.

But the solution of this burning question is this: anything created by earlier centuries *can* today, insofar as it is still usable, be copied. The forms of new phenomena in our culture (railway carriages, telephones, typewriters, etc.) must be developed without *deliberate echoes* of a style that has already been surpassed. Changes to an old object, in order to adapt it to modern needs, are not allowed. Here the important thing is either to copy or to create something completely new. But by saying that I do not mean that the new is the opposite of what has gone before.

To my knowledge this demand has never been expressed in such precise terms, although in

specialist circles abroad and, recently in the Austrian Museum, similar things can be heard. But people have been working according to this rule for years.

This demand is in fact quite obvious. The copy of an old painting is also a work of art. Who does not remember the magnificent copies of Italian old masters by Lenbach[6] in the Schack Galerie in Munich? But deliberate attempts to capture new thoughts in the style of an old master are unworthy of true art. They are always doomed to failure. Certainly a modern artist can, through a penchant and reverence for a particular master, make this manner so much his own that his intellectual products strongly bear the stamp of his master. I need only recall Lenbach's old-master tone, or the fifteenth-century figures of the English. But never can a true artist paint now *à la* Botticelli, the next time *à la* Titian and another time *à la* Raphael Mengs.

What would we think of a writer today who wrote a work in the style of Aeschylus, a poem in the style of Gerhart Hauptmann tomorrow and the day after that a farce in the style of Hans Sachs and still demonstrated the sad courage of

revealing his impotence by confessing to his models. Imagine a state school for poetry in which artistic young people were forcibly emasculated by such a doctrine, in which literary helotism was elevated to a principle. The whole world would regret the victim of such a method. And yet that school exists, although not for literature, but for arts and crafts.

But neither can we change anything about an object that we want to copy. As we feel no reverence for our own times, we lack it also for times past. We always have objections to raise about the old products. We always yield to the happy illusion that we can do something better. So we have also hounded the German Renaissance to death with 'beautiful' conditions. So changes must be made: it's called 'beautification'. But even years later we can see that these supposed beautifications were not improvements, that the old model or an exact copy of it gleams with old naivety, while its imitation, with its many 'beautifications', has become unimpeachable. Has that, though, become a salutary lesson to the practitioner of the applied arts? Far from it! He thinks only about how these beautifications have

not been radical enough. Because he doesn't like the old thing at all. Now he knows more improvements again. And after years the game started up again from the beginning, and so on into our own present day, if the new director of our Austrian Museum had not put an end to this labour of Sisyphus – we might call it ant-work – which is more comical than it is tragic. From now on, works which seek to attain a style other than the one presently seen on the Stubenring must be exact copies.

But from these perspectives – they may be correct or not, but they are the Austrian ones – how do things stand with our bronze industry? Very differently. Those things which escape the authority of the schools are, of course, once more the best. But perhaps that is precisely why they are not being shown. I mean those charming bronze bibelots which, in their natural colours, are a Viennese speciality, and which are the delight of every Graben flâneur. Under the Japanese influence, something genuinely Viennese has come into being here, something which can fill us with justified pride. I have asked about them, but always been told that there is no room

for these 'ordinary' things. With great satisfaction, however, people have pointed to the artworks that they have had made especially for the exhibition by the most celebrated architects and professors.

All styles are abused by these gentlemen. I did find one exception, but I only praise it with some misgivings. It is the religious objects in the Romanesque and Gothic styles, eras with which I am not as familiar as I am with the Renaissance. That may be the source of my pleasure in them. But it seems to me that the architect Richard Jordan has kept as precisely as possible to the old models, which we can admire in the most exquisite execution at the firm Franz Ludwig Adler & Son.

These considerations do not, of course, touch upon the purely figurative works. We see some of these by A. M. Beschorner on a monumental scale and in an execution calculated to produce precisely this effect, and the splendid bronze casts by J. Kalmar, whose exquisite technique always ensures an effect of intimacy. If only a better selection could have been made from the statues.

In everyday objects, the School of Applied

Arts sets the tone. How much effort one must go to, after all, to find a decent coal-scuttle or fire grate! And how hard it is to find good hinges for doors or windows! Over the last two decades we've given ourselves a sequence of Renaissance, Baroque and Rococo calluses from door handles, I wrote somewhere. But in Vienna there is one decent door handle not far from where I live, to which I always make a pilgrimage whenever I am near it. It is in the new house on the Kohlmarkt (Zwickl Studio) and was made by Professor König's artistic hand. But do not go there, dear readers. Otherwise you would suspect me of pulling your leg. It is as inconspicuous as that. It is worth mentioning the patented stick and cane holder by the firm of Balduin Heller and Sons, which, thank God, has no ornamentation. Consequently I cannot recommend it enough. At a time when every door handle, every window frame, every inkpot, every coal shovel, every corkscrew cries Hurrah, such modesty deserves double the support.

The brass beds that we took over from England only a few years ago, and which we liked so much because of their distinguished simplicity,

have already acclimatized themselves extremely well, and their Hurrahs now compete with those of the door handles, picture frames, coal shovels, etc. (Let us devote a moment's thought to the well-behaved ones among them, which do not come so much to the fore. We find two simple beds and a good washstand by Rudolph Kitschelt, a washstand and bedside table by Franz Thiel, an exemplary washstand at Joseph and Leopold Quittner, an exquisite child's bed by Sigmund Wisler and very good products by various bed-manufacturers. Of course no one has equalled the bed in the bedroom of court paper-hanger F. X. Schenzel and Son, designed by Otto Wagner. That would have been too much to ask. Most striking, in particular, where their discreet moulding is concerned, are all the English beds. They could compete with any in the world. Come out, you capitalists! Set up a factory devoted to making these beds in hundreds and thousands of copies.

Anton Büchler's bronze letters deserved to be stressed here too. But where the many lamps are concerned, because of the many new viewpoints, they call for a whole essay of their own.)

THE POTEMKIN CITY (1898)

Who doesn't know them, the Potemkin villages that Catherine's clever favourite built in the Ukraine? Villages made of canvas and cardboard, villages whose task it was to turn a desert into a blossoming landscape for the eyes of Her Imperial Majesty. But the clever minister is supposed to have built a whole city?

That could only happen in Russia!

The Potemkin City I want to talk about here is our own dear Vienna. A serious accusation that will also probably be hard for me to prove. Because I need an audience with a fine-tuned sense of justice that is sadly still very scarce in our city.

Anyone who makes out he is something higher than he is is a fraud and thus an object of general contempt, even if no one is harmed by it. But what if someone tries to achieve that effect with fake stonework and other imitations? There are

75

countries where the same fate would await him. But that hasn't yet happened in Vienna. Only very few people have the feeling that an immoral act, a swindle is happening here. And it is not just a matter of fake watch-chains, not only the furniture in the apartment, assembled from mere imitations, but also the apartment itself, and the building that houses it.

When I stroll along the Ring, I always feel as if a modern Potemkin were setting out to make someone believe he had been transported to a city peopled entirely by aristocrats.

Whatever Renaissance Italy produced in the way of lordly palaces was plundered to conjure up for the plebs a New Vienna that could only be inhabited by people in a position to occupy a whole palace all by themselves, from skirting-board to cornicing. On the ground floor the stables, on the low, secondary mezzanine the servants, in the high, architecturally designed *piano nobile* the halls and above them the living rooms and bedrooms. Viennese householders liked owning a palace like this, and the tenants also liked living in a palace like this. The simple man, even if he had only rented the bedroom and study on

the top floor, was overwhelmed by a feeling of feudal splendour and lordly greatness when he looked at the building he lived in from outside. Does the owner of a fake gemstone not also ogle the glittering glass? Oh, the deceiver deceived!

Some will object that I am attributing false intentions to the Viennese. The architects are to blame, the architects should not have built like that. I must stick up for the architects. Because every city has the architects it deserves. The one closest to the desires of the populace will have the most building to do. And the most proficient will perhaps pass away without ever having received a commission. But the rest are setting a trend. Then people go on building just as they're used to doing. And they have to. Ideally, the building speculator would have the façade stuccoed smooth from top to bottom. It's the least expensive way of doing things. And if he did so he would also be acting in the truest, the most correct, the most artistic way. But people wouldn't want to move into the house. Because of rentability, the architect is forced to nail on this façade, and only this one.

That's right, nail it on! Because these

Renaissance and Baroque palaces do not really consist of the material they seem to be made of. Sometimes they pretend to be built of stone, like the Roman and Tuscan palaces, sometimes of stucco, like the Vienna Baroque buildings. They are neither: their ornamental details, their corbels, fruit festoons, cartouches and dentils are nailed on to cast cement. Certainly this technique, first applied in this century, is entirely legitimate. But it should not be applied to forms closely linked with the qualities of a particular material just because no technical difficulties stand in the way of its application. The artist's task would now have been to find a new formal language for the new material. Anything else is imitation.

This has not even concerned the Viennese throughout the last few periods of architectural history. He has even been glad to be able to copy the material that served as a model with such paltry means. As a genuine parvenu he thought everyone else had failed to notice the deception. The parvenu always believes that. He confidently believes that the false shirt-front, the fake fur, all the imitated things he surrounds himself

with completely fulfil their purpose. All those who stand above him, those who have already gone beyond this parvenu stage, meaning those who know, smile at his pointless efforts. And over time even the parvenu's eyes are opened. At his friends' homes he sees one thing after another he had previously thought was authentic. Then, with resignation, he gives up.

Poverty is not a disgrace. Not everyone can be born into a feudal manor house. But to pretend such a thing to one's fellow men is ridiculous, immoral. So let us not be ashamed of the fact that we live in a house with many others who are socially our equals. Let us not be ashamed of the fact that there are materials which would be too costly for us as building materials. Let us not be ashamed of the fact that we are people from the nineteenth century, and not those who live in a house which, in its architectural style, belongs to an earlier time. You would then see how quickly we would receive our era's very own architectural style. We have it anyway, someone will object. But I mean an architectural style that we can hand down to posterity with a clear conscience, one which would be referred to proudly in the

distant future. But this architectural style has not been found in Vienna in our century. Whether one tries to use canvas, cardboard and paint to depict wooden huts in which happy peasants live or brick and cement casts to construct stone palaces in which feudal lords might have their place of residence, the principle remains the same. Above the Viennese architecture of this century there floats the spirit of Potemkin.

TO OUR YOUNG ARCHITECTS
(1898)

Is architecture still an art? It would almost seem that people are trying to deny it. The architect is granted full artistic status neither in the art world nor among the public. The most insignificant painter, the most minor sculptor, the weakest actor and the most unperformed composer lay unlimited claim to the status of artist, and the world is also happy to give it. But the architect must have achieved something outstanding before being accepted into the ranks of artists.

Two factors have served to undermine the prestige of architects. The first is the state, the second is architects themselves. The state has introduced examinations at its technical colleges, and the examinees now consider themselves justified, because they have successfully sat an examination, in using the professional title 'architect'. This farce has even gone so far that

some have wanted to approach the government with a request to give legal protection to the term 'architect' as a title for technicians who have graduated in the structural engineering department. That the whole of cultured Vienna did not break into loud and liberating laughter at the time probably shows us clearly enough how deeply the opinion has penetrated the nation through these examinations, as if architecture were a subject that one could learn, and one's mastery of it could be proved by a diploma. We need only imagine this whole development being transferred to music. Composing, so deeply close to the architect's work, should in the mind of the Conservatoire student only be granted to someone who has sat an examination at the Conservatoire. How ridiculous that would sound to us, because we still see music as an absolute art.

For the true artist, the reasons adduced by those diploma-addicted technicians are completely untenable. 'Any bricklayer's assistant can call himself an architect from now on.' And if it brings you joy, then why not? Is the fame of Beethoven and Wagner dimmed because the writer of a comic couplet calls himself a composer? Has

it done any harm to Lenbach and Menzel that any dauber can call himself a painter? Certainly not. But how ridiculous the two of them would have made themselves if they had demanded state protection for the term 'painter' because of that fact! The pen bridles at such presumption.

More even than the examination board, however, the architects have damaged themselves. They have degraded themselves, and the world has reacted. Most of our young people are, in spite of the title that they claim for themselves, in spite of their artistic talent, just architectural draughtsmen. For a month's income which matches that of a badly paid and not particularly gifted cashier, they hire themselves out to construction companies, master builders and architects whose funds allow them to keep their own studio. Their working hours are also those of a commercial worker. Whether his artistic conviction agrees with that of his paymaster is a matter of indifference to this 'architect'. In most instances he has none in any case. Today he does Gothic work, while in the next office his only salvation is the inspiration of the Italian Renaissance. And he says yes to everything. In the circle of his

like-minded colleagues he probably makes fun of his boss – you see how business-minded the language used by architects is – and thinks he's doing something extraordinary when he launches off about the old codger. And the next day, at eight o'clock on the dot, he is already fresh at work again.

If our rising artistic generation also wanted to give powerful expression to its conviction, in defiance of all financial challenges, the beneficial consequences would soon appear in the reputation of our art. Look at your brothers in painting, sculpture and music! They can starve and suffer for their art, if need be. And that is something that he must do who wants to bear the finest honorary title of all: artist!

LADIES' FASHION (1898)

Ladies' fashion! You dreadful chapter of cultural history! You tell the story of humanity's secret pleasures. If we flick through your pages, the soul quakes before the terrible aberrations and outrageous vices. We hear the whimpering of abused children, the screech of mistreated women, the terrible screams of tortured people, the wailing of those who died on the pyre. Whips crack, and the air assumes the burning stench of roasted human flesh. *La bête humaine* . . .

But no, man is not a beast. The beast lives, it lives simply as nature has decreed. But man abuses his nature, and nature abuses the Eros in him. We are beasts that are locked in stables, beasts, deprived of their natural food, beasts that must make love on demand. We are domestic animals.

If man had stayed a beast, love would have

entered his heart once a year. But the sensuality that is so arduously restrained always makes us capable of love at any time. We have been cheated of springtime. And this sensuality is not simple, but complicated; not natural, but unnatural.

This unnatural sensuality erupts in different ways every century, indeed in every decade. It hangs in the air and becomes infectious. Soon it spreads like a pestilence that cannot be hidden, soon it creeps through the land like a secret plague; the people afflicted by it know to hide it from one another. Soon flagellants are drifting through the world, and the burning pyres become a fairground, soon pleasure withdraws back into the most secret wrinkles of the soul. But be that as it may: the Marquis de Sade, the culmination point of sensuality in his day, whose mind dreamed up the most extravagant tortures of which our imagination is capable, and the sweet, pale maiden whose heart breathes more freely once she has crushed the flea, are of a single tribe.

The noble part of the female knows only one longing: to assert herself beside the big, strong man. This longing can at present be fulfilled only if she wins the man's love. Love makes her

subservient to the man. But this love is not natural. If it were, the woman would approach him naked. But the naked woman is unattractive to the man. She can arouse the man's love but not keep it.

You will have been told that modesty imposed the fig-leaf on the woman. What an error! Modesty, that emotion so strenuously constructed by refined culture, was alien to primitive man. The woman clothed herself, she became a mystery to the man, to plunge longing for its solution into his heart.

The awakening of love is the only weapon that the woman presently possesses in the battle of the sexes. But love is a daughter of desire. The desire to arouse the man's passion is the woman's hope. The man can control the woman through his position which he has achieved in human society. He is inspired by the urge for elegance, which he too expresses in his clothing. Every barber would like to look like a count, while the count will never strive to be mistaken for a barber. And in marriage the wife acquires her social standing through her husband, whether she was previously a prostitute or a princess. Her status is lost completely.

So the woman is forced to appeal to the man's sensuality through her clothing, unconsciously appeal to the man's morbid sensuality, for which only the culture of his time can be held responsible.

So while the change in men's clothing is effected in such a way that the great masses rush in their urge for elegance and in this way devalue the original elegant form, the truly elegant – or rather those who are held to be so by the crowd – must seek a new form to distinguish themselves, the change in women's clothing is dictated solely by the change in sensuality.

And sensuality is in constant flux. Certain aberrations usually accumulate in one time before making room for others. Sentences based on §§ 125–133 of our legal code are the most reliable fashion journal. I don't want to reach a long way back. In the late 1870s and the early 1880s literature was bursting with this trend, which tried to achieve an effect with their direct realism, with descriptions of opulent female beauty and flagellation scenes. I need only mention Sacher-Masoch, Catulle Mendès and Armand Silvestre.[7] Soon after this full opulence, mature

femininity was keenly expressed through clothing. Those who lacked it had to fake it: *le cul de Paris*.[8] Now the reaction set in. The call for youth rang out. The woman-child became fashionable. People craved immaturity. The girl's psyche was dissected and exploited in literature. Peter Altenberg.[9] The Barrisons[10] danced on stage and in man's soul. Then the feminine disappeared from women's clothing, to do battle against the child. She lied away her hips; strong forms, previously her pride, became uncomfortable to her. Her head acquired the expression of the child through her hairstyle and her wide sleeves. But those days are now gone as well. The objection will be raised that precisely now the jury trials of these crimes are increasing in the most terrible way. Certainly. That is the best proof that they are disappearing from the higher circles and embarking on their downward peregrination. Because the great mass do not have at their disposal the means to escape that oppressive atmosphere.

A large and constant draught passed through this century. Becoming had a stronger effect than that which had become. It was not until

this century that spring became the most favoured season. The flower paintings of earlier times never painted buds. The professional beauties at the court of the French kings only achieved their fullest flowering at the age of forty. But today, even for those who consider themselves to be in perfect health – consider themselves, I say – this point in the development of women has been raised upwards by twenty years. Hence women always choose styles that bear the features of youth. One piece of evidence: place the photographs from the last twenty years of a woman's life side by side. And she will exclaim: 'How old I looked twenty years ago!' And you too will have to admit: she looks youngest in the last picture.

As I have already observed, there are also parallel trends. The most important of these, whose end is still impossible to predict, and the strongest because it emerges from England, is the tendency invented by refined Hellas – Platonic love. The woman is only a good comrade to the man. This trend was also accommodated and led to the creation of the tailor-made costume, the dress made by a master tailor. But in that

stratum of society in which the wife's elegant lineage was also a matter of interest, in the aristocracy, where chamberlain status meant that the wife's lineage was still apparent generations later, we may observe an emancipation from the dominant ladies' fashion, in that aristocracy there is recognized according to the male line. Then people cannot be amazed enough by the simplicity that prevails in the aristocracy.

This tells us that the man with the highest social position holds the leading role in gentlemen's clothing, but the leading role in ladies' fashion is held by the woman who must develop the greatest finesse when it comes to arousing sensual feelings, the prostitute.

Women's clothing differs outwardly from men's in its preference for ornamental and colourful effects, and the long skirt that completely covers the woman's legs. These two elements alone show us on their own that women have remained far behind in their development over the last few centuries. No cultural era has known such a difference in the clothing of the free man and the free woman as our own. Because in earlier times men also wore clothes whose hems reached the

ground, colourful and richly decorated. The magnificent development that our culture has undergone this century has happily overcome ornament. Here I must repeat myself: the lower the culture, the more apparent the ornament. Ornament is something that must be overcome. The Papuan and the criminal ornament their skin. The Indian covers his oar and his boat all over with ornaments. But the bicycle and the steam train are free of ornament. As culture advances, it excludes object after object from being decorated with ornaments.

Men who wish to stress their relationship with previous eras today dress in gold, velvet and silk: magnates and the clergy. Men from whom we wish to withhold one modern achievement, self-determination, we dress in gold, velvet and silk: lackeys and ministers. And on special occasions the monarch dresses himself in ermine and purple, whether it corresponds to his taste or not, as first servant of the state. For the soldier, too, the sense of bondage is heightened by colourful uniforms dripping with gold.

But the long cloak reaching to the knuckles is the common insignia of those who do not do

physical work. When physical and gainful activity was still irreconcilable with free, noble descent, the lord wore the long dress, the servant the trousers. It is still so in China: mandarin and coolie. By the same token, the clergyman emphasizes the non-gainful nature of his activity with the cassock. The man in the top layers of society has probably acquired the right to free labour, but on solemn occasions he still wears a piece of clothing that reaches to his knees, the frock coat.*

Women from these circles were not permitted gainful employment by their society. In the classes in which they achieved the right to gainful employment, they too wear trousers. We might think of the female coal-miners in the Belgian pits, the dairywomen in the Alps, the crayfish fisherwomen of the North Sea.

Men also had to fight for the right to wear trousers. Riding, an activity directed solely towards the purpose of physical education and not material

* In England, at audiences with the Queen, at the opening of Parliament, at weddings, etc., the frock coat is worn, while in backward states tails are worn on the same occasions.

gain, was the first stage. Men owe their ankle-length clothing to the flourishing, horse-riding knightly caste of the thirteenth century. The sixteenth century, when riding fell out of fashion, could not strip them of this accomplishment. It is only over the past fifty years that women achieved the right to physical education. A similar process: like knights in the thirteenth century, twentieth-century women cyclists were granted the right to clothes that left the feet free, and to trousers. And thus is the first step taken towards the social sanction of women's work.

Women's nobility knows only one longing: to assert herself beside the big strong man. At present this longing can be fulfilled only if she wins the man's love. But we are approaching a new and greater time. Women's equality with men is prompted no longer through an appeal to sensuality, but rather through the economic and intellectual independence of women as achieved by work. Women's value or lack of it will not rise and fall with changes in sensuality. Then velvet and silk, flowers and ribbons, feathers and paints will lose their effect. They will disappear.

THE OLD AND NEW DIRECTION IN ARCHITECTURE (1898)

A parallel with particular reference to the artistic situation in Vienna

It does seem to me that architecture is the last among the visual arts to adapt to the prevailing trends of the day. The painting, the etching, the sculpture owe their creation to a happy thought, and the artwork can be passed on to the world after weeks or months. Not so the building. Even the preliminary works call for an intellectual and artistic activity of years, and their execution can last a lifetime.

But it now becomes all the easier for us, on the basis of the transformations that the other arts have already been through, to guess the new directions that architecture will take. Architecture, an art of space and form (unlike the view that seeks to include architecture among the graphic arts), will be particularly influenced by sculpture. We see how over the course of the century a social trend has made itself apparent, and one which

has already taken hold in sculpture at present: craft is coming into its own once more.

Until recently we were living in a curious time, which saw the brain-worker as everything and the hand-worker as nothing. In social terms, the man in the blue apron, however proficient he might have been, was far below the ill-paid little clerk in the office. The arts too were gripped by this madness: wherever it was applicable, actual craft was left to the slavishly labouring craftsman. The same probably did not apply to painting. The sculptor, however, only modelled the miniaturized sketch. The sculpting work, the technical mastery of the material, was alien to him. But the architect did not even move from his office, and produced his plans perhaps without having seen the setting for his artistic activity. He left everything up to the craftsman. The most ambitious architects, after proposed changes had been ruled out, probably went to the building site and cursed and raged at the stupid craftsman who had not of course followed their design intentions to the letter. They forgot, in fact, that the craftsman is a human being and not a machine.

The English efficiently swept away the notion

of the inferiority of craft. If you want to make a pot, don't design some notional geometrical figure, but sit down at the potter's wheel yourself. If you want to make a chair, don't spend ages doing sketches all over the place, but pick up your chisel. They took the artist into the workshop and threw out the challenge, '*Hic Rhodus, hic salta*'.[11]

Now the reaction occurred. Where it had once been vulgar to work in the workshop, now it became the height of elegance. Sculptor N. N. will carve his bust of Danaë in multicoloured marble with his own hand. The artist who was not afraid to wield hammer and chisel, to learn the stonemason's craft, was the focus of interest. He no longer stood, as he once had done, below his colleagues who only drew and modelled, but above them. The number of sculptors who did not want to leave their work to a mindless copying machine or a stone sculptor with different ideas grew and grew.

Architecture too will have to do justice to this requirement of the age. The architect will work more on the building-site, he will pay attention to his decorative ornamentation only

once the space has been created and its lighting established. The completely superfluous and time-consuming drawing of ornamental natural details will be abandoned. In the studio itself, perhaps even on the spot, the master will be able to model the decoration from a sketch and undertake the corrections with his own hand, after precise study of the lighting and the removal of the viewer. Of course, that will make big demands on his time. This means that he will build less. The large construction offices, veritable factories of house-building, will disappear.

But what will the buildings executed in this way look like? We may assume that they will present themselves in a much more conservative manner than our hotheads imagine. Because the art of construction is connected with emotions and habits influenced by the continuous use of already existing buildings that have lasted for millennia.

What does the architect actually want? With the help of the materials he wants to arouse emotions in people that do not yet in fact inhabit these materials. He builds a church. People are to be put in the mood for worship. He builds a bar. People are supposed to feel congenial there. How

does one do that? One checks to see what buildings in the past have been capable of producing those feelings. Those are the ones with which one must connect. For throughout his life man has prayed in certain spaces, drunk in certain spaces. The feeling is learned, not innate. Consequently the architect, if he is at all serious about his art, must take these learned emotions into consideration.

We might think that what delighted us 500 years ago can no longer do so today. Certainly. A tragedy that would have moved us to tears back then will only mildly interest us today. A joke from back then will no longer tickle our funny bones. The tragedy is no longer performed, the joke is forgotten. But the building remains in the midst of changing posterity, and hence it becomes explicable that architecture, in spite of all other changes in the zeitgeist, will remain the most conservative art.

For there is one emotion that we cannot erase from our memory: the acknowledgement of the superiority of classical antiquity. Now that this is obvious to us, all Gothic, Moorish, Chinese, etc. styles are completely finished. They may

influence the Renaissance, and have always done so, but a great spirit, I should like to call him the uber-architect, will always be able to free architecture from alien ingredients and give us back the pure, classical style of building. And again and again the people hail that man, because we are classicists in thought and feeling. After the great master-builders of the Italian Renaissance countless little masters turned up in Germany, full of good ideas, full of overflowing imagination; who knows their names? Schlüter arrived in the north, Fischer von Erlach in the south, Le Pautre in France. Men of classical-Roman sensibility, and again we can record a peak. And again it goes downhill, again the unbounded delight in form took hold and produced architects whose names will only be wrested from oblivion by research. Here appears Schinkel, the great tamer of the imagination and, again after a downward motion, Semper; so we see that the palm is always awarded to the artist who has made the fewest concessions to his time, and who has most recklessly represented the classical position. For the architect creates not only for his own time; posterity too has the right to be able to enjoy his work.

One needs only a fixed and immutable measure, both contemporary and for the future, until perhaps a great event evokes a complete revaluation, classical antiquity.

So we may assert: the great architect of the future will be a classicist. One who follows on not from the work of his predecessors, but directly from classical antiquity. He will have a much richer formal language at his disposal than the great master-builders of the Renaissance, the Baroque or the Schinkel-Semper schools. For old discoveries have been supplemented by the results of more recent archaeology; there is also the fact that the Egyptians, Etruscans, Mesopotamians, etc. are gradually arousing our interest as well. There are hints of this even in the new ornamentalism of the Wagner school.

So now we know: the future architect will have to make his own contribution and be classically trained. Indeed, we may make the following demand: among all professions, that of the architect is the one that most strictly requires a classical training. But in order to do justice to the material needs of his time, he must also be a modern person. He must not only be very well acquainted

with the cultural needs of his time, he must himself be at the top of that culture. For he has it in his power to give certain cultural forms and practices a different character. Thus he would never lead the culture downwards, but upwards.

But the future architect must also be a gentleman. The times are over when all those who did not steal were honest. Today Aristides would not be celebrated for his poverty. That is obvious to us. We are becoming more and more sensitive to justice and injustice. As a final consequence of this we now make the following conclusion: the architect must also not lie in relation to the material. This demand is probably fulfilled in the fact that the architect himself must bring everything in the material to execution. For the craftsman does not know this lie. It was only introduced to architecture by the architect-draughtsman.* But as the architect cannot master

* Here we sometimes encounter apparently justified objections. We might thus refer to the stucco-lustro works of the Italian Renaissance. That is, after all, direct imitation of marble. To that I would reply that the old marble-workers were trying to imitate less the material than the magnificent drawing of marble. The stonemason who wants to

all materials equally (in fact everyone can master only one), a specialism will form, of the kind adhered to in earlier times: the architect in stone (stonemason)* and the architect in brick (brick-layer), the architect in stucco (plasterer) and the architect in wood (cabinet-maker). You want a stone church, then fine, you go to the stonemason. You want a bare brick barracks. The bricklayer makes it. You want a stucco residential house. You give the contract to the plasterer. You want a wooden ceiling in the dining room. The cabinet-maker will do it.

Yes, but – someone will object – where is the similar artistic training? I insist that it is

transfer a mask, an acanthus, a festoon to his material does the same thing. But the old marble-workers, unlike their modern successors, have never tried to imitate hairline cracks. On the contrary: in the working of large planes without cracks they recognized the advantage over real marble. I call that a true, proud spirit of craftsmanship, against which our wretched stuccoers look like pathetic frauds, constantly afraid of being caught in the act.
* See the greatness in the title: Friedrich Schmidt, a German stonemason. As we know, Cathedral Master-Builder Schmidt refused to be seen as an architect. He always stressed his artisanal calling.

unnecessary. No one will deny that magnificent buildings were made in former times in this way. A building all of whose details, down to the key-plates, were the product of a single mind, loses all its freshness and becomes boring. Always the same ornament, always the same profile, now a little bigger, now smaller, on the façade, on the front door, in the hall, in the mosaic floor, in the roof lantern, in the wallpaper. What a glorious room is the golden hall in the Augsburg Town Hall. And yet it owes its existence to two artists: the master builder Elias Holl for the spatial effect and the master carpenter Wolfgang Ebner for the wonderful ceiling. But the similar artistic training is already rendered illusory by the division of labour. As so often, two or even three architects come together to form a firm, and the actual execution is left to an army of draughtsmen. How easily that is modified by an artist, the boss, making the sketch, while the details are left to draughtsmen who have also learned their craft. The boss himself will probably correct but will happily concur with his colleague's specialist judgement. But the artist himself will have to master one of the four crafts listed above.

I have captured what our intelligence can grasp, without drawing utopian conclusions. These impulses apply to the present and the immediate future. I did not think it necessary to examine whether social upheavals will produce new forms and thoughts. Because at present the capitalist view of the world still prevails. And my reflections apply only to that.

BUILDING MATERIALS (1898)

What is worth more, a kilo of stone or a kilo of gold? The question is probably ludicrous. But only for the businessman. The great artist will answer: for me all materials are equally valuable.

The Venus de Milo would be equally valuable whether it was made of gravel stone – in Paros the streets are gravelled with Parian marble – or of gold. The Sistine Madonna would not be worth a penny more if Raphael had mixed a few pounds of gold in with his paints. The businessman who has to think about melting down the gold Venus in an emergency, or scraping down the Madonna, will probably have to do a different sum.

But the artist has only one ambition: to master the material in a way that makes his work independent of the value of the raw material. But our architects don't know this ambition. For them,

a square metre of granite façade is more valuable than if it were concrete.

And yet granite is essentially worthless. You can find it lying outside in the field. Anyone can go and get it. Or it forms whole mountains, whole mountain ranges, which just need to be dug up. Streets are gravelled with it, towns cobbled with it. It is the most common stone, the most ordinary material known to us. And yet there are supposed to be people who consider it to be our most valuable building material?

These people say material and mean work. Human labour power, skill and art. Because granite demands a lot of work to wrest it from the mountain, a lot of work to bring it to its destination, work to give it the right shape, work to give it a pleasing appearance. And at the sight of the polished granite wall our heart will lift in respectful terror. At the material? No, at the human labour.

So does this mean that granite is indeed more valuable than concrete? Not necessarily. For a wall with stucco decoration by the hand of Michelangelo will put even the best-polished granite wall in the shade. Not only the quantity,

but the quality of the work on offer will help to determine the value of any object.

We live in an age that prefers the quantity of work. For it is easily checked, it is easily apparent to the man in the street, and does not require a practised eye or any other knowledge. There are no mistakes. So and so many day labourers have worked on it for so and so many kreutzers. The man in the street can work that one out. And they want to make the value of the things with which we surround ourselves comprehensible to the man in the street. Otherwise those things would be pointless. Then those materials that require a longer working time will be better respected.

This was not always the case. In the old days building was done with materials that were most easily accessible to anyone. In some areas the wall was covered with brick, in some with stone, in others with cement. Did the people who built in that way feel of lesser value than the architects in stone? It would not have occurred to anyone. Had they had stone quarries nearby, they would, in fact, have built in stone. But bringing stone to the building site from far away

seemed to them to be more of a question of money than a question of art. And in the old days art, the quality of the work, was of greater importance than it is today.

But such times also yielded proud, powerful characters in the field of architecture. Fischer von Erlach didn't need granite to make himself understood. Using clay, chalk and sand, he created works that grip us as strongly as the best constructions from materials that are difficult to work. His spirit, his artistry mastered the most wretched material. He was capable of giving plebeian dust the nobility of art: a king in the sphere of materials.

But in our own times it is not the artist who rules, but the day labourer; not creative thought, but working time. And mastery is also being progressively twisted from the hands of the day labourer, because someone has turned up who can produce the quantitative performance better and more cheaply: the machine.

But all working time, whether accomplished by machine or coolie, costs money. But what if one has no money? Then one begins to fake working time, to imitate material.

Respect for quantity of work is the caste

of craftsmen's worst enemy. For it leads to imitation. But imitation has demoralized a large proportion of our craft. All pride and craftsmanship has fled from them. 'Book printer, what can you do?' 'I can print so that it looks like a lithograph.' 'And lithographer, what can you do?' 'I can make a lithograph look as if it's printed.' 'Cabinet-maker, what can you do?' 'I can carve ornaments that look as stylish as if a plasterer had made them.' 'Stucco plasterer, what can you do?' 'I imitate mouldings and ornaments so precisely, I make hairline joints that everyone thinks are real, so that they look like the best stonemasonry.' 'I can do that too!' the tinsmith exclaims proudly, 'if you paint and sand ornaments, it would never occur to anyone that they are made of tin.' Unhappy society!

A spirit of self-vilification runs through our trade. It should come as no surprise that this class is not in a good way. Such people are not supposed to be in a good way at all. Chin up, cabinet-maker, be proud that you are a cabinet-maker. The plasterer also makes ornaments. You should walk past them without envy or desire. And you, plasterer, why are you concerned about

the stonemason? The stonemason makes joints, must sadly make joints, because small stones are more cheaply got hold of than large ones. Be proud that your work does not show the petty joints that carve up column, ornament and wall, be proud of your job, be glad that you are not a stonemason!

But I am wasting my breath. The public does not want a proud craftsman. Because the better one can imitate, the more one is supported by the public. Respect for expensive materials, the surest sign of the parvenu stage at which our people finds itself, would not have it otherwise. The parvenu finds it shaming not to adorn himself with diamonds, shaming not to be able to wear fur, shaming not to live in stone palaces, since he has come to learn that diamonds, fur and stone façades cost a great deal of money. He is unaware that the lack of diamonds, fur or stone façades has no influence on elegance. So since he lacks money he reaches for surrogates. A ludicrous undertaking. For those that he wishes to deceive, the ones whose means would enable him to surround himself with diamonds, furs

and stone façades, cannot be deceived. They find such efforts comical. And for the subordinates they are once again unnecessary, if one is aware of one's superiority.

Over the past few decades imitation has dominated the whole of architecture. The wall covering is made of paper, but on no account is it to show the fact. So it had to be given silk damask, gobelins or carpet patterns. The doors and windows are made of soft wood. But because hard wood is more expensive, they had to be painted as such. Iron had to imitate bronze or copper through applications of those metals. But in the face of precast concrete, an achievement of this century, one was entirely helpless. It is a magnificent material in itself, but the only thought about how to apply it, the same thought that comes to mind with every new material, was: what can it be used to imitate? It was used as a surrogate for stone. And since precast concrete is so extraordinarily cheap, it was wasted on a most substantial scale. The century was gripped by a real plague of concrete. 'Ah, my dear Mr Architect, can you not apply five guilders more to the façade?' the vain

client probably said. And the architect nailed as many guilders of art to the façade as were demanded of him, and sometimes rather more.

At present precast concrete is used to imitate the plasterer's work. It is typical of the situation in Vienna that a man vigorously opposed to the rape of material, to imitation, was dismissed as a materialist. Just look at the sophistry: they are the people who place so much value on material that they shrink from no lack of character for its sake and reach for surrogates.

The English have brought us their wallpapers. Unfortunately they cannot send over whole houses. But from the wallpapers we can see what the English want. They are wallpapers that are not afraid to be made of paper. And why should they? There are doubtless wall coverings that cost more money. But the Englishman is not a parvenu. In his home one will never think that the money must have run out. Even the fabrics of his clothes are made of sheep's wool, and honestly reveal the fact. English fabrics, our fabrics, therefore, do not display the Viennese attitude of 'I'd love to, but I can't', even though they are made only of wool.

And so we reach a chapter that plays the most important role in architecture, with the principle that was supposed to constitute every architect's ABC, the principle of cladding. The explanation of that principle shall be reserved for the next chapter.

THE PRINCIPLE OF CLADDING
(1898)

If all materials are equally valuable to the artist, it does not mean that they are all equally fit for all his purposes. Solidity and manufacturability demand materials that do not harmonize with the actual purpose of the building. Here the architect has the task of producing a warm, inhabitable room. Carpets are warm and inhabitable. So he decides to spread one of those on the floor and to hang up four carpets, which are to form the four walls. But you can't build a house from carpets. Both the carpet on the floor and the tapestries on the walls demand a structural scaffolding that anchors them in the correct place. The invention of that scaffolding is only the architect's second task.

That is the correct, logical path that architecture is taking. For that is the order in which humanity learned to build. In the beginning was

cladding. Man sought shelter against the horrors of the weather, shelter and warmth as he slept. He sought to cover himself. The ceiling is the oldest architectural detail. Originally it consisted of animal hides or fabrics, a meaning preserved in the Germanic languages even today.[12] This ceiling had to be anchored somewhere, if it was to provide sufficient shelter for a family. Soon it was joined by the walls, to provide shelter from the sides as well. And in this sequence the idea of building developed both in humanity and in the individual.

There are architects who do that differently. Their imagination creates not spaces but wall sections. What the wall sections leave over are spaces. And for those spaces the type of cladding that is thought suitable for them is added afterwards. That is art accomplished empirically.

But the artist, the architect, first feels the effect that he is seeking to produce and then with his mind's eye he sees the spaces that he wants to create. The effect that he wants to make on the viewer, whether it be fear or horror, as in a prison; the fear of God, as in a church; respect for the power of the state, as in a government building;

piety, as in a funeral monument; homeliness, as in a residential house; congeniality, as in a drinking-hall: this effect is prompted by the material and by the form.

Every material has its own formal language, and no material can lay claim to the forms of another material for itself. Because forms have arisen out of the usability and mode of production of every material, they have developed with the material and out of the material. No material permits an intervention into its range of forms. Anyone who tries such a thing will be branded by the world as a forger. But art has nothing to do with forgery, with lies. The paths of art may be thorny, but they are clean.

The tower of St Stephen's Cathedral could be cast in concrete and placed somewhere or other – but then it would not be a work of art. And what applies to the steeple of St Stephen's also applies to the Palazzo Pitti, and what applies to the Palazzo Pitti also applies to the Palazzo Farnese. And with this building we would be right in the middle of our Ringstrasse architecture. A sad time for art, a sad time for the few artists among the architects of those times who were

forced to prostitute their art for the sake of the rabble. Only a few were in the happy position of finding clients who thought grandly enough to allow the artist to carry on. The luckiest of these was probably Schmidt.[13] He was followed by Hansen,[14] who, if he felt out of sorts, sought comfort in terracotta building. Poor Ferstel[15] must have endured terrible torments when he was forced at the last minute to nail on whole parts of the façade of his university in precast concrete. The other architects of the day, with a few exceptions, were free of such sickly sentimentality.

Are things different today? Allow me to answer that question. Imitation and surrogate art still prevail in architecture. More than that, in fact. Over the last few years a number of people have come forward to defend this trend – one of them anonymously, admittedly, since the issue struck him as a little ambiguous – so that the surrogate architect no longer needs to stand quietly aside. Now the construction is nailed with aplomb to the façade, and the stone upright is hung with artistic justification beneath the main cornice. Come, ye heralds of imitation,

come ye manufacturers of mocked-up carvings, bodge your home windows and your papier mâché tankards! A new spring is dawning in Vienna, the soil is freshly manured.

But is a living room decorated entirely with tapestries not an imitation? The walls are not built of tapestries, after all. Certainly not. But those tapestries claim only to be tapestries and not bricks, they don't want to be mistaken for bricks, they show that neither through their colour nor their pattern, but clearly reveal their significance as a cladding of the surface of the wall. They fulfil their purpose according to the principle of cladding.

As I mentioned at the outset, cladding is older than construction. The reasons for cladding are manifold. Firstly it is a protection against inclement weather, like an application of oil paint to wood, iron or stone; then it is for reasons of hygiene, such as glazed tiles in a lavatory to cover the surface of the wall; then it is the means to a particular effect, like the colourful painting of statues, the papering of walls, the veneering of wood. The principle of cladding, first declared by Semper, also extends to nature. Man is clad with a skin, the tree with bark.

But the principle of cladding also has its own particular law. No need for alarm. Laws, it is commonly said, bring all developments to an end. And besides, the old masters also managed perfectly well without laws. Of course. But where theft is unknown there would be little point in making laws to forbid it. When the materials used for cladding were not yet imitated, there was no need to work out laws. But now it seems to me to be high time.

So this law is as follows: the possibility of confusing the cladded material and the cladding shall be ruled out in every case. Applied to individual cases, this clause would read: wood may be painted with every colour, except one – wood colour. In a city whose Exhibition Commission decided to paint old wood in the Rotunda 'like mahogany', in which graining is the only painted decoration of wood, this is a very bold statement. There seem to be people hereabouts who find it elegant. It does not seem so to me. And neither do I find it beautiful. As railway and tramway carriages, like all forms of carriage, come from England, they are the only wooden objects that display absolute colours. I now dare to assert that

I would rather see such a tramway carriage – particularly those from the electric line – in absolute colours than, following the beauty principle of the Exhibition Commission, if it were painted like mahogany.

But there is a true sense of elegance slumbering in our nation, albeit buried and hidden away. Otherwise the tram company would not be able to count on the fact that the brown-painted – wood-coloured – third class awakens less elegant feelings than the green first and second.

I once demonstrated this unconscious feeling to a colleague in a rather dramatic way. On the first floor of a building there were two apartments. The tenant of the first apartment had had the mullions and transoms, which were otherwise painted a grained brown, painted white. We had had a bet, whereby we would invite a certain number of people in front of the house and ask them, without drawing their attention to the difference in the mullions and transoms, on which side they thought Herr Blunzengruber lived and on which side Prince Liechtenstein, the two parties that we allowed ourselves to have renting the house. The wood-grained side was unanimously held to belong

to Blunzengruber. Since then my colleague has only painted white.

Wood-graining is, of course, an invention of our century. In the Middle Ages wood was predominantly painted bright red, in the Renaissance blue, in the Baroque and the Rococo white for the inside, green for the outside. Our farmers have retained sound enough sense to paint in absolute colours. How charming in the countryside are the green gate and the green fence, the green shutters against the white, freshly painted wall. Unfortunately some villages have made our Exhibition Commission's taste their own.

We might recall the moral outrage that arose in the surrogate applied arts camp when the first furniture painted with oil paint came from England to Vienna. It was not the painting that aroused the fury of those good citizens. Even in Vienna, as soon as soft wood had come into use, it had been painted with oil paint. But the fact that the English furniture dared to display its oil paint as frankly and freely, instead of imitating hard wood, really raised the hackles of these queer characters. They rolled their eyes and pretended never to have used oil paint. Presumably

these gentlemen are of the opinion that their wood-grained furniture and buildings have hitherto been seen as hard wood.

If such observations in my outline of these painters prefer not to name names, I think I can be sure of the gratitude of the fraternity.

Applied to plasterers, the principle of cladding would read: stucco can be given any ornament but one – bare brickwork. We might imagine that there is no need to utter something so obvious, but it is only recently that my attention has been drawn to a building whose plastered wall was painted red and given white joints. That very popular kitchen decoration that imitates stone blocks falls under the same heading. And so all materials that serve to disguise walls – wallpaper, tarpaulin, fabrics and tapestries, tiles and stone blocks – should not be used for representation.

A cladding material can keep its natural colour if the covered material is the same colour. So I can paint black iron with tar, I can cover wood with a different wood (veneer, marquetry, etc.), without having to paint the covering wood; I can coat a metal with a different metal using fire or by galvanizing. But the principle of cladding

forbids copying the material beneath with a coloured substance. Hence iron can be tarred, painted in oil paint or be galvanically coated but can never be hidden with bronze paint, in other words a metal paint.

Here it is worth mentioning chamotte[16] and artificial stone plates, which on the one hand imitate terrace plaster (mosaic) and on the other Persian carpets. Certainly there will be people who believe it – the factories must know their clientele.

But no, you imitators and surrogate architects, you are making a mistake. The human soul is too elevated and sublime for you to dupe it with your little tricks and tactics. You have our pitiful bodies in your power. They have only five senses at their disposal to distinguish the authentic from the fake. And where man with his sensory organs is no longer enough, that is where your domain begins, that is your realm. But once again, you are mistaken. Paint your best inlays very, very high up on the ceiling, and our poor eyes will believe the lot. But the divine psyche does not believe your deceit. In the best-painted, 'as if inlaid' intarsias it senses only the oil paint.

UNDERWEAR (1898)

I recently had an argument with an acquaintance. What I wrote on matters of applied art was fair enough. But the subjects of fashion and cladding went against the grain. He accused me of wanting to make the whole world uniform. What would then become of our glorious national costumes?

Here he grew lyrical. He remembered his childhood, remembered the glorious Sundays in the little Styrian town, remembered the country folk gathering in ceremonial garb to go to church. How magnificent, how lovely, how quaint! How different things are now! Only old people still wore the old costumes. The young were already aping city folk. I would be better off trying to win the people back to the old costumes. That would be the task of someone culturally literate.

'So you liked the old costumes?' I asked him. 'Certainly.' 'So you would like those costumes

to be preserved for all time?' 'That is my deepest wish!'

Now I had him where I wanted him. 'You know,' I said to him, 'that you are a very mean and egoistic person. You know that you want to exclude a whole class, a great and glorious class, our farming class, from all the blessings of civilization. And why? So that, when you go to the countryside, your eye is quaintly titillated! Why do you not walk around like that yourself? Ah, you owe them your profoundest gratitude. But you demand of other people that they act as accessories in the landscape, so as not to insult your intoxicated artist's eye. Yes, you go there and act the yokel for the councillor of commerce who wants to enjoy the unadulterated Alps. The farmer has a higher mission to fulfil than that of stylishly populating the mountains for the summer trippers. The farmer – the saying is nearly a hundred years old – is not a toy!'

Even I myself must admit that I am very fond of the old costumes. But that doesn't give me the right to demand of my neighbour that he wear them for my sake. The costume, clothing frozen in a particular form that does not develop any

further, is always the sign that its wearer has given up changing his situation. The costume is the embodiment of resignation. It says: I have to give up trying to win myself a better position in my struggle for existence. When the farmer was still fighting, fresh and cheerful, when he was filled with the most naive hopes, it would not have occurred to him in his wildest dreams to wear the same frock coat that his grandfather had worn. The Middle Ages, the Peasants' Revolt, the Renaissance did not cling rigidly to sartorial forms. The difference between the clothing of the city-dweller and the peasant was caused only by their different ways of life. City-dweller and peasant related to one another in those days as city-dweller and farmer do today.

Then the peasant lost his independence. He became a bondservant. And bondservant he had to remain, he and his children's children. Why should he make an effort to rise above his surroundings by changing his outfit, by introducing a change to his clothing? There was no point. The peasant class became a caste, and the peasant was cut off from any chance of escaping that caste. Nations that have divided themselves into

castes all have one trait in common: rigidly cling-ing for centuries to national costumes.

Then the peasant was freed. But only out-wardly. Inwardly he still feels inferior to the city-dweller. He is the master. The peasant still has centuries of servitude in his limbs.

But now a new generation comes along. It has declared war on national costumes. And it has a strong ally: the threshing machine. Wherever this turns up, the quaint clobber is finished. It now goes where it belongs: in the fancy-dress hire shop.

These are heartless words. But they have to be said, because in Austria, out of fake sentimen-tality, associations have even been formed with a view to maintaining the mark of the peasant's servitude. And yet we have even greater need for associations that do the reverse. Because even we city-dwellers are still a long way away from the clothing that the great civilized peoples wear. Outwardly we look quite passable. In those terms we keep up with the others. We can, if we are dressed by one of the premier Viennese tailors, even be mistaken for civilized Europeans in London, New York and Peking. But woe to us if the surface of our clothing were to fall away one

piece at a time and we were left standing there in our underwear! One would become aware that we only put on our European clothing as a kind of disguise, because beneath it we still wear the national costume.

But either-or. We have to make our minds up. Whether we have the courage of the conviction to separate ourselves from the rest of humanity and put on a national costume. Or we stick with the rest of humanity and dress ourselves as they do. But wanting outwardly to act the part of the modern civilized human, and pulling the wool over the eyes of others with those items of clothing that are not accessible to strange eyes, does not indicate an elegant way of thinking. While in our outer clothing a whole world separates us from the countryman, our underclothes, our underwear, is no different from that of the peasant. In Hungary they wear the same underpants as the Csikos, in Vienna the same as the peasant from Lower Austria. What is it that distinguishes our underwear so very clearly from the other civilized nations?

It is the fact that we are at least fifty years behind the stage that England has fought to

reach, between machine-knitted underwear and woven underwear. In our outer clothing we have not been able to show any revolutions over the course of this century. They are all the more radical in underclothing. A hundred years ago we still wrapped ourselves entirely in linen. But in the course of this century we have gradually set about granting the machine-knitting producer his place again. We proceeded gradually, from body part to body part. We started with the feet and worked our way up. At present the whole of the lower body belongs to the knitter, while the torso must still put up with the singlet being disguised by a linen shirt.

They started with the feet. We occupy that position as well. We too wear socks rather than foot-cloths. But we still wear linen underpants, an item of clothing that has already died out in England and America.

If a man from the Balkan states who still wears foot-cloths were to come to Vienna and look for an underwear shop to buy the footwear common in his country, he would receive the ungraspable information that foot-cloths are not on sale. But he could probably order one. Yes,

what do the people here wear? Socks. Socks? That is very uncomfortable. And too hot in summer. Does no one wear foot-cloths any more? Oh yes, the very old people. But the young people find foot-cloths uncomfortable, in fact. The good fellow from the Balkan states then decides with a heavy heart to give socks a go. In so doing, he has reached a new stage in human civilization.

Philippopel[17] is to Vienna as Vienna is to New York. So there let us try to buy – not foot-cloths, they wouldn't even understand us – but linen underpants. I must ask the reader to read the previous dialogue through again, changing the words 'man from the Balkan states' to 'Viennese' and 'foot-cloths' to 'canvas underpants'. Because it would play out in exactly the same way. I speak from my own experience. The original dialogue would take place, with only 'foot-cloths' needing the context of Vienna in order to make sense.

Let anyone who finds the woven fabrics more comfortable than the machine-knitted ones go on wearing them. Because it would be nonsense to impose on people a cultural form that does not correspond to their innermost nature. The fact is

that at the peak of civilization linen becomes uncomfortable. So we must wait until we Austrians also feel their discomfort. The increasing prevalence of physical exercise, of sport, which comes from England, also leads to an aversion to linen underwear. Starched shirt fronts, collars and sleeves are also detrimental to sport. The unstarched shirt-front is the predecessor of the unstarched collar. Both have the task only of paving the way for the singlet and the flannel shirt.

But tricot underwear contains a great danger. It is in fact meant only for people who wash for their own sake. But many Germans see putting on machine-knitted underwear as a licence not to have to wash. But all inventions designed to spare washing come from Germany. Germany gave us celluloid underwear, false shirt fronts, ties with matching dickey. From Germany comes the theory that washing is bad for the health, and that one can wear a tricot shirt for a year – as long as those around do not seriously refuse to tolerate it. For the American, the German is entirely incomprehensible without a gleaming white but fake shirt front. That is proved by the caricature

of the German concocted by the American satirical papers. The German can be recognized by the tip of the shirt front, which always sticks out of his waistcoat. According to the American caricaturists, only one other class of people wears the false shirt front: the tramp, the man of the road.

The fake shirt front is really not a symbol of angelic purity. It is all the more pleasant that this piece of clothing, sad for the state of civilization of any nation, is to be found in every section of the exhibition in which our best tailors have shown their work. That moves the whole elegant exposition, in which the names Ebenstein, Keller and Uzel appear, in which one of the most elegant fashion magazines has exhibited, down a few notches. The gentlemen should have steered well clear.

We know the shop of the 'English Fleet' (chief supplier E. H. Berger). Another two of our very first 'outfitters' exhibited: Berecz & Löbl and Goldmann & Salatsch. The latter firm in particular has introduced a very new type of business to Vienna, one that is already taken for granted in other cities:

Tailors and outfitters. Their exposition also contains what their name suggests. One interesting thing in it is the sheep's wool material, which, thanks to its combination with reindeer hairs, can keep the person wearing it afloat, an Austrian invention designed to provoke a revolution in water-sport clothing.

The *outfitter* stocks everything to do with men's suits. His task is not an easy one. With every article he sells, his responsibility to the customer is to create an elegant impression. We may demand of a well-run fashion shop that no object chosen at random should be tasteless or inelegant. The outfitter can make no concessions to the great mass. The excuse that other tastes must be accommodated must never be used by a shop of the first rank. He must never be wrong. If he has made a mistake, he has an obligation to his customer to remove the item in question from his shop. Truly, no easy task. Because it is hard to acquire a leading role in the fashion world, but even harder to maintain that role. And yet only the smallest part of the goods is produced in his workshop. He is a trader first and foremost. He is to the craftsman what the collector or the director of an art gallery

is to the artist. They too have the obligation to select the best from the abundance of created material. That is intellectual work enough to fill a human life.

We must express this thought when we are swamped by anonymous messages usually voicing the 'suspicion' that someone I have discussed favourably does not produce his goods himself. Even if I spotted something along those lines, I could not set about tracing the provenance of the goods. I am not a detective. But I am indifferent to where they were produced. The main thing is that the businessman is capable of providing these goods with this degree of workmanship. Whether he has his own workshop or farms the work out to a number of different workshops is irrelevant to the objects. For my observations concern only him.

The exposition of the textile fabric producers also contains excellent goods. One seeks in vain, however, for white machine-made underwear, the only correct kind. As we know, these days even our ladies wear white and bluish-white stockings, or are these perhaps only worn in Vienna?

Maison Spitzer displays ladies' underwear

of great accomplishment. Schostal & Härtlein is also making outstanding work. That one finds so many pre-knotted ties for women is saddening. Even on men these loops of cloth look very vulgar. The necktie that shows a knot or a bow at the front and is held together at the back belongs in the same category as paper underwear and fake gemstones. I will not even mention those ties that are tied twice around the neck, and which seek to achieve this beautiful effect with the help of a piece of cardboard covered with silk material, and some kind of 'patent': the favourite necktie of our suburban sophisticate. But the fact that our Viennese girls and women use such surrogates instead of tying their own ties shows that the much-vaunted Viennese elegance is dying out. I wish there were a shop in Vienna whose owner could proudly answer to anyone who asked for a pre-knotted tie: Pre-knotted ties? No! We don't stock them!

FURNITURE (1898)

The interiors on display in our Jubilee Exhibition can be divided into three categories. The first tries to copy old furniture as faithfully as possible, the second wants to be modern, and the third is trying to adapt old furniture to new needs.

Today I want to look at the first category. I have already dwelt at length on the second in the essays about the Otto Wagner room, and the other rooms are to be discussed next time. But I must pass over the third category in silence.

I think it is possible, if not to honour a dead master, then at least to show him so much respect that one leaves his works untouched. It would be a degradation of the spirit of Raphael if we were to produce a copy of the Sistine Madonna in that way, repainting the green curtain in ruby-red, giving the two angels different heads and

replacing St Sixtus and St Barbara with St Aloysius and St Ursula. Don't overstate your case, I hear the cabinet-maker saying. Certainly, I would never do that. Raphael was a painter. But if we were talking about a piece of cabinet-making . . .

The great cabinet-makers of the Renaissance and the Baroque, however, are said to have been revered by their pupils as much as our painters revere the Old Masters. Professional honour required it. One can do new things in painting and carpentry, one can copy old things, copy them strictly, as strictly as is possible in our time, until we abandon our own identity, but those who deliberately lay hands on the old masters receive a hearty 'Hands off!'

Some might object that there is little sense in copying what the masters could not have done otherwise. The glass is poor and only comes in small pieces. The great master, if he had had our highly developed glass industry at his disposal, would certainly have made use of it.

Of course he would. But then he would also have chosen another subject for a painting on glass: he would have produced a different design. These supposed improvements always end badly.

These figures and this arrangement suit only this material, and if a modern glass were used, modern figures would also have to be drawn. If you dislike something about the old master, then leave him entirely alone. But it would be megalomania to try to improve him.

I will be frowned upon in some circles for standing up for copying. Other centuries didn't copy. That is particular to our own time. Copying, the imitation of old stylistic forms, however, is a consequence of our social conditions, which have nothing in common with those of previous centuries.

The French Revolution freed the middle classes. Nothing could stop them from acquiring money and using it as they saw fit. They could use it just as the aristocrat did, or even the king. They could ride in gold coaches, wear silk stockings and buy palaces. Why shouldn't they? That was even their duty. There are people who still gravitate towards the *ancien régime*. However, they say, I now have the right to dress like the Prince of Wales. But I am not a king's son. I am just an ordinary member of the bourgeoisie. No, my dear bourgeois, you not only have the right,

you also have a duty to dress like the Prince of Wales. Remember that you have ancestors. Your great-grandfather and your father fought for it, perhaps they even spilled their blood. A king and an empress's daughter had to lose their heads for this idea on the scaffold. Now it is up to you to make the correct use of what they won.

Our middle classes soon worked out how the prince dressed. Because clothes wear out quickly, and when these can no longer be worn, one orders new ones. Now it was an easy matter to go to the same tailor and say to him: *répète*. But living was another matter. The aristocracy and the royal family had an abundance of old furniture that kept them going for a long time, for centuries, even. Why should one throw money out of the window just for the sake of innovation? On the contrary: they were glad of the old possessions that distinguished them from the now wealthy bourgeoisie. Because in the days when they still held power, the middle class could not afford to buy such things. They did not have access to unoccupied ceremonial halls to act as store rooms. The middle classes used their furniture up. If they wanted to surround themselves with

the same things, they were forced to make copies of them.

That isn't a mistake. It may look like the actions of a parvenu, but it is the elegance of the parvenu. The desire to surround oneself with copies or depictions of old cultural products that one likes, but whose originals are out of one's reach, is certainly very human. A photograph of an old building, a cast of a sculpture, a copy of a Titian can bring back the happy sensations that one felt when looking at the originals.

Three firms have worked towards this end. Sadly only three, because the creations of the others, apart from the few who worked in a modern way, belong to the third category.

These three, who will be discussed subsequently, are: Sándor Járay, Bernhard Ludwig and J. W. Müller.

We may recall the struggle that Sandor Jaray had last year with the director of our Museum of Applied Art, Privy Councillor von Scala. But when we look at Jaray's exhibition, we wonder with amazement: what was the fuss about? With his fundamental principles Privy Councillor von Scala incited opposition on the part of the

current powers-that-be in the School of Applied Art and the Applied Art Associations. The first principle, which I implemented initially, and which is now followed in all civilized countries, is: copy, but copy strictly. The second is: the English set the tone for modern furniture-making. Both principles are vehemently opposed in the aforementioned camps. They think they can always create new things in the spirit of a different age. They do not feel that the idea of a gothic gas chandelier is just as nonsensical as that of a gothic locomotive. But the second principle, obviously because the word 'English' appears in it, is like a red rag.

Let us see how Sandor Jaray opposes Herr von Scala by what he does. He exhibits a drawing room in the style of Louis XV, an Italian Baroque dining room, a drawing room in the – according to Ilg – 'style of Maria Theresia', an Empire drawing room, all faithful copies, and now comes the modern, the – *horribile dictu* – room of an English lord. But we can see that Sandor Jaray preaches the Applied Art Association, but practises Privy Councillor von Scala.

While I once had to speak out in harsh terms

against the theorist Jaray, I lack sufficient words of praise for his work as a practitioner. One can say with confidence: never has a Viennese applied artist offered anything more accomplished in all his pieces, both in terms of quality and quantity. But certainly the quantity is remarkable, because it takes an eminent workforce and performance, while continuing with normal production, to produce such a number of objects worth looking at for the same occasion. What the Viennese art industry has to offer in terms of significant decorative talents were brought in to furnish the dining room. We see sopraportas by Matsch, a fireplace by Schimkowitz, reliefs by Zelezny and lunettes by Makart. Wherever the eye falls, there is no flaw to be seen. Everything is a strict copy, strict in the spirit of the age. And that is a skill, a very significant skill. Because it is much easier to paint a new Madonna in Raphael's manner than to do justice to the Sistine Madonna.

As well as three modern rooms, Bernhard Ludwig has exhibited a drawing room, a copy of a room in the Bishop's Palace in Würzburg. Walls, ceiling and furniture are produced in Vernis Martin's green, a charming effect, but one

that is only within the means of people who can also construct a red drawing room, in order to have somewhere to go quickly, if necessary – and it will be necessary – for a few minutes as an antidote.

J. W. Müller is showing a lord's room in the German Renaissance style. How quaint, how tasteful! It is unparalleled in terms of its lovingly efficient joinery. What respect for the skill of the old master is revealed in every line, every fitting! Nothing was changed, even the old German 'unbeautiful' proportions, probably the severest test for the sensibility of modern man, were retained. Quite rightly. Because here it is a matter of either-or. How beautiful! How glorious! The modern, efficient Viennese master helping his old colleague from the sixteenth century to victory. What does Hans Sachs say through Richard Wagner? Honour your German masters, then you will conjure up good spirits. Now we know: Sándor Járay, Bernhard Ludwig and J. W. Müller are good spirit-conjurors.

CHAIRS (1898)

The Otto Wagner room – the modern bedroom and bathroom in the Applied Art section of the Craft Association – is beautiful, not because but despite the fact it was produced by an architect. This architect has in fact become his own decorator. For anyone else this room would be incorrect because idiosyncratic, and hence imperfect, and thus we would be unable to speak of beauty. That is indeed a contradiction.

By beauty we mean supreme perfection. It is thus completely out of the question that something impractical can be beautiful. The first fundamental condition for an object that wants to lay claim to the label 'beautiful' is that it does not offend against functionality. But the practical object on its own is not yet beautiful. More is required. The people of the Cinquecento probably put it most precisely. They said: an object

that is so perfect that one could not add anything to it or take anything away without adversely affecting it is beautiful. That would be the most perfect, the most complete harmony.

The beautiful man? He is the most perfect man, the man who, through his physique and his intellectual properties, can offer the best guarantee of healthy descendants and for the upkeep and feeding of his family. The beautiful woman? She is the perfect woman. She applies herself to arousing the man's love, breastfeeding the children herself and giving them a good upbringing. She also has the most beautiful eyes, practical, keen eyes, rather than short-sighted and stupid ones, she has the most beautiful forehead, the most beautiful hair, the most beautiful nose. A nose through which one can breathe well. She has the most beautiful mouth, the most beautiful teeth, teeth that are best for grinding food. Nothing in nature is superfluous; the degree of usefulness, together with harmony with the other parts, is what we call pure beauty.

So we see that the beauty of a useful object can only be explained in terms of its purpose. For the object there is absolute beauty. 'Look,

what a lovely desk!' 'Desk? It's ugly!' 'But it isn't a desk, it's a billiard table.' 'So, a billiard table, certainly, it's a beautiful billiard table.' 'Oh, look, what magnificent sugar tongs!' 'Whaaat, magnificent, I think those sugar tongs are dreadful!' 'But that's a coal shovel!' 'Right, then, yes, it's a magnificent coal shovel!' 'What a wonderful bedroom, Herr – put the name of the stupidest person you know – owns.' 'What, Herr X.Y.Z.? You think that's wonderful?' 'I was wrong, it belongs to Senior Architectural Councillor Professor Otto Wagner, C.M. (Club Member), the greatest architect of his time.' 'Then it is indeed wonderful.' The most beautiful, quaintest *osteria* would be ugly to anyone but Italian peasants. And the people would be right.

And the same is true of every individual utility object. Are, for example, the chairs in the Wagner room beautiful? Not for me, because I find them hard to sit on. Everyone else will probably feel the same. But it is quite possible that Otto Wagner sits very comfortably on these chairs. For his bedroom, a room in which one does not welcome guests, they are thus, as long as my assumption is correct, beautiful. They are

formed like Greek chairs. But over the millennia the technique of sitting, the technique of resting has undergone a significant change. It never stood still. It is different in all peoples and in all ages. Postures which would be for us extremely strenuous, other people – we need only think of people from the East – might see as restful.

At present we not only demand of a chair that we can rest on it, but also that we can rest on it *quickly*. Time is money. So resting must be specialized. After intellectual work one will have to rest in a different posture from that after movement in the open. After gymnastic exercises differently from after rowing. Indeed, still more. The degree of fatigue requires a different technique of resting. This, to hasten resting, will happen through several physical positions and postures. Have you never had the need, particularly when extremely tired, to hang one foot over the arm of the chair? Essentially a very uncomfortable posture, but sometimes a real blessing. In America one can always achieve that blessing, because there no one considers comfortable sitting, or quick resting, to be inelegant. There you can put your feet up on a table that isn't being

used for eating. But here we find something insulting in the comfort of our neighbour. There are still people whom one can irritate by putting one's feet on the opposite seat in a railway carriage, or even by lying down.

The English and Americans, who are free of such petty ways of thinking, are also genuine virtuosi in the art of resting. In the course of this century they have invented more types of armchair than in the whole world, all peoples included, since they have existed. According to the principle that every kind of fatigue calls for a different armchair, the English room never shows an entirely identical type of armchair. All kinds of seating opportunities are represented in the same room. Anyone can choose the seat that suits him best. One exception is constituted by those rooms which are only used temporarily for the same purpose by all occupants. Thus, for example, the dance hall and the dining room. But the drawing room, our salon, will according to its definition have light and hence easily transportable chairs. These are not there for resting on, however, but to offer seating for light and stimulating conversation. It is easier to chat on

small, capricious chairs than in a grandfather chair. So such chairs – they could be seen last year at von Scala's Christmas exhibition in the Austrian Museum – are also made by the English. The Viennese, who either didn't know what they were for or perhaps have in mind a patent chair for all seating eventualities, thus called them impractical.

In general, we should be very cautious in our use of the word 'impractical'. I have previously indicated that under certain circumstances an uncomfortable posture can be comfortable. The Greeks, who required of a chair that it should allow great play for the bending of the spine – we need only think of the crouching figures of Alma-Tadema – would also find our seatbacks uncomfortable, as we want to have our shoulder-blades supported. And what would they say to the American rocking chair, with which we don't even know where to start? We proceed, in fact, from the principle that one has to swing in a rocking chair. I think that this false idea has arisen out of a misnomer. In America, in fact, the chair is called a 'rocker'. But the word 'rocking' also refers

to a seesawing, back-and-forth motion. The rocker is in principle nothing but a chair with two legs in which the seated person's feet must form the front legs. So it has arisen out of the comfortable seat that one creates when one moves one's centre of gravity backwards, so that the front legs are raised. The back runners of the chair keep it from tipping over. The American rocker does not have front runners, like our swing chair, since it would not occur to anyone over there to sway. For this reason, in some American rooms we see only rockers, while here they are very unpopular.

So all chairs should be practical. Hence if only practical chairs were built for people, they would be given the opportunity to furnish their homes completely without the help of a decorator. Perfect furniture creates perfect rooms. So let our paper-hangers, architects, painters, sculptors, decorators, etc., where living rooms as opposed to state rooms are concerned, limit themselves to the use of perfect, practical furniture. At present in this respect we rely on English imports, and can therefore unfortunately give

our cabinet-makers no better advice than to copy these types. Certainly our cabinet-makers would have made similar chairs without any influence, if their contact with life had not been severed. Because differences between the craft furniture of a single cultural outlook and a single time are so small that they would strike only a great connoisseur.

It seems very peculiar that, at the turn of our century, voices were heard demanding an emancipation from the English influence in favour of an Austrian national style. Applied to bicycle construction, this would sound more or less like this: abandon the reprehensible copying of English products and take the genuine Austrian wooden bicycle by the Upper Styrian farm hand Peter Zapfel – was that his name? – as your model. This bicycle is definitely better suited to the Alpine landscape than the ugly English bicycles. And for this trend that seems to be the main thing.

From century to century furniture has increasingly assumed features of kinship in outward form. Even as early as the beginning of this century, it was difficult to tell the difference between

a Viennese and a London chair. That was at a time when one had to spend weeks in the mail coach to get from Vienna to London. And now there are queer fish who, in the age of express trains and telegrams, want to build a Great Wall of China around us. But that is impossible. Identical food will lead to identical cutlery, identical work and identical rest in an identical chair. But it would be to sin against our civilization if we challenged ourselves to abandon our eating habits and, like a peasant, to eat with our whole family from a single bowl just because otherwise the way we eat comes from England. The same applies to sitting. Our habits are much closer to those of the English than to those of the Upper Austrian peasant.

So our cabinet-makers would have achieved the same results if they had been given free rein, and the architects hadn't got involved. If the same pace had been maintained in the assimilation of forms as had been adopted from the Renaissance to the time of the Congress of Vienna, there would also be no difference in cabinet-making between countries, just as such differences ceased long ago to exist in the blossoming architect-free crafts:

in car construction, jewellery, in leather fashion accessories. For there is no difference between the vision of a London cabinet-maker and one from Vienna, while between a London cabinet-maker and a Viennese architect there lies a whole world.

GLASS AND CHINA (1898)

'Show me the pots that a civilization has produced, and you can generally tell what it was like, and at what stage of civilization it was,' Semper says in the preface to his book on ceramics. This revelatory power is not only inherent in pots, one might add. Any utilitarian object can tell us of the customs, the character of a people. But ceramic products possess this quality to a particular degree.

Semper immediately gives us an example. He uses the illustration of one vessel that women used to bring water home in Egypt and one in Greece. The former is the Nile bucket, the *situla*, which bears a casual resemblance to those copper vessels with which Venetians scoop their water. It resembles a giant pumpkin, cut off at the top, has no foot and a handle like a fire pail. This water-bucket can reveal to us the whole of the country's creativity, its topography and

hydrography. We know straight away: the people that use this vessel must live on the plain, on the shores of a sluggish river. But how different it is from the Greek vessel! Semper says of this one: '. . . the hydria, whose purpose lies not in scooping water but in catching it as it flows from the spring. Hence the funnel shape of the neck and the kettle shape of the body, whose centre of gravity is as close to the mouth as possible; because Greek and Etruscan women carried their hydrias on their heads – upright, if full, horizontal, if empty. Anyone who attempts to balance a stick on his fingertip will find the trick easier if he puts the heavier end of the stick at the top: this experiment explains the basic form of the Hellenic hydria (the body in fact resembles a heart-shaped turnip), which is completed by two horizontal handles at the level of the centre of gravity, for lifting of the vessel when full, and a third, vertical, handle for carrying it and hanging it up when empty, perhaps also as a grip for a third person who stands by the water-carrier, to lift the full vessel on to her head.'

So much for Semper. He has doubtless stung the hearts of idealistically minded people. What,

those wonderful Greek vases with their perfect forms, forms that were made only to tell of the Hellenic people's urge to beauty, owe their shape to simple utility alone? The foot, the body, the handle, the size of the mouth were dictated entirely by use? And these vases are *practical* after all! When we always thought they were *beautiful*! How could such a thing even happen to us! Because we have always been taught that the practical excludes the beautiful.

In my last article I dared to claim the opposite, and as I received so many letters proving to me that I was wrong, I must take up my hiding place behind the ancient Greeks. I do not want to deny that our applied artists stand on a level that completely excludes comparison with another people or another age. But I would like to suggest that the ancient Greeks also knew something about beauty. And they only worked practically, without even thinking for a moment about beauty, without trying to pursue an aesthetic need. And if an object was so practical that it could not be made more practical, they called it beautiful. And so did the peoples who came after them; and we too say: these vases are beautiful.

Are there still people who work as the Greeks did? Oh, yes. There are the English as a people, engineers as a class. The English, the engineers, are our Greeks. From them we have our civilization, from them it spreads over the whole globe. They are the people of the nineteenth century in all its perfection . . .

Those Greek vases are beautiful, as beautiful as a bicycle. In this respect our ceramics can by and large not be measured against the products of mechanical engineering. Of course not from the Viennese perspective, but from the Greek. The superfluous – here it becomes a sensation. At the start of the century our ceramics were very much in the wake of the classical. Here too the architect intervened 'to save it'.

I once saw an operetta, which was of course set in Spain. On the occasion of a joyful celebration – I think it was the birthday of the master of the house – a choir of *estudiantes* was brought in to offer the composer the opportunity of a Spanish song, and the costume designer activity for so and so many ladies' roles. They sing – whether for a wedding, a birth, a christening, an anniversary or a name day, they don't mind – because

We have only one song
That fits all needs.
We are here on the spot, etc., etc.

The magic song is:

For he's a jolly good fellow, and so say all of us.

I am only quoting from memory, it must be twenty years ago now.

These *estudiantes* were our architects. They too knew only a single song. It had two verses: profile and ornament. And with *the same* profile and *the same* ornament everything was worked and reworked. Façades and briefcases, inkpots and pianos, key-rings and displays. Also glass and china goods. First a line was drawn, that was the central axis. Then, on the right or the left depending on whether the artist was right- or left-handed, he profiled away, profiled so much that it was a joy to behold. The profiles just flowed from the pencil. Bandelet, cove, bandelet, ogee, bandelet, cove, bandelet, and in between the occasional cornice. Then this profile was traced over, and the ceiling rose was complete. Now came verse

two: ornament. That too was solved with the help of the geometry with which, as the song has it, the content of the cucumber could not be explained: 'With the help of geometry you will never measure the content of the cucumber' – but the ceiling rose could be elaborated. In short it was glorious.

Then the wicked English came along and dimmed the joy of the gentlemen from the drawing board. They said: don't draw, do. Go into life, so you know what's needed. And when you have completely grasped life, then go and stand by the foundry or the potter's wheel. In that case 99 per cent of artists would give up pottery. We haven't got quite that far. But the English spirit has also entered our craftsmen and is rebelling against the predominance of architects. With secret joy I recently heard a colleague complaining to me that a potter had openly declared that he couldn't work from his design. He refused even to try. There was no point even asking. The man is right, I told the architect. He probably thought I was an idiot.

It is high time for our trade to think about itself and try to reject any unwanted guidance. Anyone who wants to join in is welcome: anyone

who wants to stand by the whirring potter's wheel in his smock, or by the glowing foundry with a naked torso, shall be praised. But let those dilettantes who wanted, from the vantage point of their comfortable studios, to prescribe to the artist, art means skill, to the creator, to tell them what to create, let them restrict themselves to their own field, that of graphic art.

The emancipation of the craftsman came from England, and hence new objects all show English forms. Also from England came the new cut glass that we call *Steindlschliff* or *Walzenschliff*. Lines of prismatic cross-hatching form a geometrical design across the whole of the glass. The rectilinear design is given the first name, the curvilinear the second. Here we have reached a level with this technique where we can already compete with America (a country where it has reached its prime), which should come as no surprise, given the dexterity of our glass-cutters. But many things are finer, more elegant, more distinguished in terms of form. American cut glass always displays an exuberance of form that does not strike me as contemporary. Almost all exhibitors have good samples.

Count Harrach's glass factory in Neuwelt is showing, probably for the first time, Tiffany glasses produced on Austrian soil. The son of the American goldsmith Tiffany, Louis C. Tiffany, has, with the help of Venetian glass-workers and using the latest achievements of the 'glass flux' technique, discovered a new principle for the decoration of glass. These pieces are made not by grinding or painting, but by a clever process of immersion in different-coloured molten glass while it is being blown – unlike the Venetian method, in which different pieces are melded together during the blowing process. This forms vessels which represent the very best that modern art can offer us. The objects from the New World are very tame particularly in terms of their colouration. But none the less a start has been made, and with any luck it will also bring artists into the glass factory.

We cannot speak with such confidence about the china industry. Porcelain painting clings to the time-honoured tradition of the previous century. In stoneware and majolica there are forms, forms! There one finds among other things an ashtray made of the concave shield of our imperial

house. Is there no College of Heralds that could get involved? In glassware there is certainly a great deal of inferior work. We pass over that in silence. But in the ceramics section we read the confident inscription: 'All designs and forms are legally protected in all countries.' Good God! Should we not be legally protecting all countries from these designs and forms? Such thoughts must surely occur to us in the face of so much tastelessness.

We seek in vain for works like those produced by the Royal Copenhagen Factory, recently Meissen, Rookwood in Cincinnati, the Germans Läuger, Schmutz-Baudiss and Heider. A glorious material – new, very new – is in evidence, an Austrian invention – eosin. But the hand of the artist that will give it a fitting decoration has so far been still. Things like Raguenet ornaments – in the oriental art section – or imitations of marbled enamel crockery don't fit the bill. Stay fine and delicate: the Raguenet ornament seems more appropriate to eosin.

In the big exposition by the Ernst Wahliss company the patterned plates, along with the large dinner services they have delivered in the past, are

a delight for any art-lover. Here the company has reached a height unparalleled in the world. All the royal houses and aristocrats by wealth or title in all parts of the world have their porcelain services manufactured here. Here the plates of the Indian rajah and the American Croesus sit side by side. Like a symbol of the beginning of the dominance of a global culture, like a symbol of uniform English food and levelling Viennese taste.

ORNAMENT AND CRIME (1908)

In the womb, the human embryo passes through the entire phase of evolution corresponding to the evolution of the animal kingdom. And when the human being is born, his sensory impressions are like those of a new-born puppy. His childhood passes through all the transformations that correspond to the history of mankind. At the age of two he sees like a Papuan, at the age of four like a Teuton, at six like Socrates, at eight like Voltaire. At the age of eight he becomes aware of purple, the colour that the eighteenth century discovered. Because before then the violet was blue and the indigo snail-red. Even today, physicists are pointing to colours in the solar spectrum that already have a name, but which will be known only to the human beings of the future . . .

The child is amoral. For us, so is the Papuan.

The Papuan slaughters his enemies and devours them. He is not a criminal. But if modern man slaughters and devours someone, he is a criminal or a degenerate. The Papuan tattoos his skin, his boat, his rudder, in short everything that lies to hand. There are prisons in which 80 per cent of the inmates have tattoos. The tattooed people who are not in jail are latent criminals or degenerate aristocrats.

The urge to ornament one's face and everything that lies to hand are the primal origins of visual art. It is the babbling of painting. But all art is erotic.

The man of our own times, who follows his innermost urgings to smear the walls with erotic symbols, is a criminal or a degenerate. What is natural in the Papuan and the child is a manifestation of degeneracy in modern man. I have made the following discovery and given it to the world: *the evolution of culture comes to the same thing as the removal of ornament from functional objects*. I thought that by saying this I was bringing joy into the world, but the world has not thanked me. People were sad and hung their heads. What oppressed them was the realization

that they would not be able to produce any new ornaments. What, those things that any Negro could do, which all peoples and ages before us have been able to do, we alone, the people of the nineteenth century, are not capable of doing them? Those things that mankind in earlier millennia made without ornament were heedlessly rejected and cast into oblivion. We have no workbenches from Carolingian times, but any trash revealing even the smallest ornament was collected and cleaned, and magnificent palaces were built to house it.

And we walked sadly from one display case to the next, ashamed of our impotence. Every age has had its style, and ours alone should be denied one?! And by style they meant ornament. And I replied: weep not. Behold, this is what constitutes the greatness of our age, that it is not capable of producing a new ornament. We have overcome ornament, we have fought our way through to ornamentlessness. Behold, the time is at hand. Fulfilment awaits us. Soon the streets of the cities will gleam like white walls! Like Zion, the holy city, the capital of heaven! Then fulfilment will have come.

But there are Black Elves who will have none of it. Humanity should go on wheezing in the slavery of the ornament. Human beings had come so far that ornament produced no feelings of pleasure in them, so far that a tattooed face did not increase aesthetic feelings as they did in the Papuan, but reduced them. So far that they could take pleasure in a smooth cigarette box, while they refused to buy an ornamented one at the same price. They were happy in their clothes, and glad that they didn't have to go around in velvet breeches with gold laces like monkeys at a funfair. And I said: behold, Goethe's death chamber is more glorious than any Renaissance splendour, and a smooth piece of furniture more beautiful than any carved and inlaid museum pieces. Goethe's language is more beautiful than all the ornaments of the Nuremberg baroque poets.

The Black Elves heard all this with displeasure, and the state, whose task it is to halt the development of their peoples, took the question of the development and reception of ornament and made it its own. For woe to the state whose revolutions are fought by court counsellors.

Soon a sideboard was seen in Vienna's Museum of Art and Craft, called 'The Rich Catch of Fish', soon there were wardrobes bearing the name 'The Enchanted Princess', and other similar names referring to the ornament with which these unfortunate pieces of furniture were covered. The Austrian state saw its task as precisely to ensure that footwraps did not vanish from the borders of the Austro-Hungarian monarchy. It forces every cultured twenty-year-old man to spend three years marching in footwraps rather than machine-knit footwear! Because in the end every state proceeds from the assumption that a lowly populace is more easily governed than a cultured one.

Well, the ornament plague has state recognition in Austria and receives a financial subvention. But I see it as a backward step. I cannot accept the objection that ornament enhances a cultured person's joy in life, I cannot accept the objection couched in these words: but what if the ornament is beautiful! Ornament does not enhance my joy in life, nor does it that of any cultured person. If I want to eat a piece of gingerbread, I choose a piece that is quite smooth, not a piece

depicting a heart or a babe in swaddling or a knight covered from head to toe in ornaments. A man from the fifteenth century will not understand me. But all modern people will. The advocate of ornament believes that my urge for simplicity is like self-mortification. No, my dear professor from the School of Arts and Crafts, I am not mortifying myself. I find it tastes better that way.

The terrible damage and the devastation wrought by the awakening of ornament in aesthetic development can be easily got over, because no one, not even a state power, can halt the evolution of mankind! It can only be delayed. We can wait. But it is a crime that human labour, money and material are thus wrecked in economic terms. Time cannot heal that damage.

The pace of cultural development suffers from stragglers. I may be living in 1912, but my neighbour is living in around 1900, and that man over there in 1880. It is unfortunate for a state if the culture of its inhabitants extends over too long a period of time. The Tyrolean peasant lives in the twelfth century. On the occasion of the Jubilee festival procession we learned with horror

that we in Austria still have tribes from the fourth century. Lucky the land that no longer has these stragglers and marauders! Lucky America! Here, even in the cities we have unmodern people, stragglers from the eighteenth century, who are horrified by a painting with violet shadows, because they can't yet see the colour violet, who prefer the taste of a pheasant that the cook has worked upon for days and who like a cigarette-box with Renaissance ornaments better than a smooth one. And what is the situation in the countryside? Clothes and household equipment all belong to earlier centuries. The peasant is not a Christian, he is still a heathen.

These stragglers slow down the cultural development of the nations and of humanity. In economic terms, when two people living side by side, with the same needs, the same demands on life and the same income, belong to different cultures, we can observe the following process: the man of the twentieth century becomes richer and richer, the person from the eighteenth century poorer and poorer. I assume that both live according to their inclinations. The man of the twentieth century can cover his needs with much

less capital, and thus make savings. The vegetables that he likes have been cooked simply in water and have then had a little butter poured over them. The other man likes them only if honey and nuts have been added, and if someone has cooked away at them for hours. Ornamented plates are more expensive, while the other man likes his food only from white crockery. One makes savings, the other runs up debts. It is the same with whole nations. Woe betide that a nation is left behind in its cultural development. The English are growing richer while we grow poorer . . .

Even greater is the damage that a productive nation suffers on account of ornament. As the ornament is no longer a natural product of our culture, and hence represents neither backwardness nor a manifestation of degeneracy, the ornament-maker's work is no longer paid appropriately. The situation in the crafts of wood-sculptors and wood-turners, the criminally low prices that knitters and lacemakers are paid, are well known. The ornament-maker must work for twenty hours to achieve the income of a modern manual worker who works for eight hours.

Ornament as a rule makes objects more expensive, but sometimes it may happen an ornamented object with the same material costs, and which has demonstrably been worked on for three times longer, is offered for half the price that a smooth object costs. The lack of ornament leads to a shortening of working time and a rise in price. The Chinese carver works for sixteen hours, the American worker for eight. If I pay as much for a smooth vase as for an ornamented one, the difference in working time belongs to the worker. And if there were no ornament at all – a situation that may occur in millennia to come – a person will need to work not eight but only four hours, because half of the work is now still devoted to ornaments.

Ornament means squandered manpower and thus squandered health. It has always been so. But today it also means squandered material and both together mean squandered capital.

As the ornament is no longer organically connected with our culture, ornament is no longer the expression of our culture. The ornament that is made today has no connection with us, it has no human connections, no connection with

the world order. It is not capable of development. What happened to the ornament of Otto Eckmann,[18] what to Van de Velde's?[19] The artist at the tip of humanity was always full of power and health. The modern ornamentalist, however, is a straggler or a pathological phenomenon. He himself repudiates his products after three years. Cultivated people find them unbearable straight away, and others only become aware of how unbearable they are after a number of years. Where are Otto Eckmann's works now? Where will the works of Olbrich[20] be in ten years' time? The modern ornament has no parents and no descendants, has no past and no future. It is greeted with delight by uncultivated people to whom the greatness of our age is a book with seven seals, and repudiated shortly afterwards.

Humanity is healthy, and only a few are sick. But those few tyrannize the worker, who is so healthy that he cannot invent ornaments. They force him to make the ornaments they have invented in a great variety of materials.

The turnover of ornaments leads to a premature devaluation of the product of labour. The worker's time, the material used, are wasted capital.

I have expressed it thus: *Let the form of an object last for as long, that is, let it be bearable to us, for as long as the object lasts.* I will try to explain it like this: a suit will change its form more often than a valuable fur. A woman's ballgown, meant only for one night, will change its form more quickly than a writing-desk. But woe betide that we must change the desk as quickly as a ballgown, because the old forms have become unbearable; then one will have lost the money spent on the desk.

Ornamentalists know this very well, and Austrian ornamentalists try to make the best of this shortcoming. They say: 'A consumer who has a piece of furniture that he finds unbearable after only ten years, and is therefore forced to buy new furniture every ten years, is better than one who only buys an object when the old one has become unusable through wear. Industry needs it. Millions are kept in employment by the rapid turnover!' This seems to be the secret of the Austrian economy, because how often do we hear, at the outbreak of a fire, the words: 'Thank God, now the people have something to do again!' Set fire to a house, set fire to the Empire, and everything is swimming in money and affluence.

Make pieces of furniture that one can put on the fire in three years, metal fittings that need to be melted down after four years because one cannot achieve a tenth of the labour and material costs, and we become richer and richer.

The loss does not only affect the consumer, it affects the producer above all. Today ornament on things which thanks to development have escaped being ornamented means squandered manpower and desecrated material. If all objects lasted as long aesthetically as they do physically, the consumer could pay a price for them that would make it possible for the worker to earn more money and work fewer hours. For an object which I am sure I can fully use and exploit, I will happily pay four times as much as I would for another that I could buy. I happily pay forty crowns for my boots even though I was offered boots in another shop for ten crowns. But in those crafts which languish under the tyranny of the ornamentalists, good or bad work is not evaluated. The work suffers because no one can be bothered to pay their true value.

And that is fine, because these ornamented things only seem bearable in the shabbiest

execution. I can cope more easily with a fire when I hear that only worthless trash has been burned. I can be glad of the tat in the Artists' House, because I know that it will be put up in a day and taken down in a day. But throwing gold coins rather than pebbles, lighting a cigar with a banknote, pulverizing and drinking pearls seem unaesthetic.

Ornamented things only seem truly unaesthetic when they are executed in the best material, with the greatest care, and have demanded long hours of work. I must take responsibility for having demanded quality work. The furnishing of the Apollo Candles Factory Depot in Vienna in soft wood, colourfully stained, which was carried out fourteen years ago, does not look nearly as unbearable as Professor Hoffmann's contemporary works. Or what Hoffmann's works will look like in fourteen years. But the café that was opened at the same time as that commercial business will only look unbearable when the woodwork comes apart.

The modern person who considers ornament wholly as a sign of artistic excesses from past times will immediately recognize the tormented,

laboriously wrought and morbid aspect of modern ornaments. No ornament today can be produced by someone who lives on our cultural level. The same cannot be said of people and nations which have not yet reached this stage.

I preach to the aristocrat, I mean he who stands at the top of humanity and yet has the deepest understanding of the urgency and necessity of that which has not yet come into being. The Kaffir who, following a particular rhythm, works into the fabric ornaments that only become apparent when one pulls them apart, the Persian knotting his carpet, the Slovak peasant-woman making her lace, the old lady teasing wonderful things out of glass beads and silk – all of these he understands very well. The aristocrat lets them get on with it, he knows that these are their sacred hours. The revolutionary would go and say, 'It's all nonsense.' Just as he would pull the little old woman from the wayside cross and say, 'There is no God.' But the atheist among the aristocrats raises his hat when he passes a church.

My shoes are covered all over with ornaments that come from spikes and holes. Work that the cobbler did, and which he wasn't paid for. I go to

the cobbler and say: you demand thirty crowns for a pair of shoes. I will pay you forty crowns. By doing that I have raised this man to a spiritual height for which he will thank me through work and material whose goodness will far surpass the extra payment. He is happy. Seldom does happiness enter his house. Here stands a man who understands him, who values his work and has no doubts about his honesty. In his mind the finished shoes already stand before him. He knows where the best leather is to be found at present, he knows which worker he will entrust the shoes to, and the shoes will have jags and holes, as many as an elegant shoe has room for. And now I say: but I have one condition. The shoe must be quite smooth. Now I have plunged him from the most spiritual heights into Tartarus. He has less work, but I have taken all his joy from him.

I preach to the aristocrat. I can bear ornaments on my own body when they bring delight to my fellow man. They are my joy. I can bear the ornaments of the Kaffir, the Persian, the Slovakian peasant-woman, the ornaments of my cobbler, because they have no other way of reaching the

summits of their existence. We have the art that has supplanted ornament. Once the day's toil and labour is over we go to Beethoven or to *Tristan*. My cobbler cannot do that. I must not take his religion from him, as I have nothing else to put in its place. But anyone who goes to the Ninth and then sits down to draw the pattern is either a fraud or a degenerate.

The lack of ornament has taken the other arts to unimagined heights. Beethoven's symphonies would never have been written by a man who had to walk around in silk, velvet and lace. Anyone who walks around in a velvet jacket today is not an artist, but a buffoon, or a house painter. We have become finer, subtler. The people of the herd had to distinguish themselves with various masks, modern man does not need clothes as a mask. His individuality is so terribly strong that it is no longer expressed in items of clothing. The lack of ornament is a sign of intellectual power. Modern man uses the ornaments of former and foreign cultures on a whim, as he sees fit. His own inventiveness is concentrated on other things.

MATTERS OF VIENNESE
ARCHITECTURE (1910)

There is something unique about a city's architectural character. Every city has its own. What would be beautiful and charming in one city might be ugly and repellent in another. The bare brickwork buildings of Danzig would lose all their beauty at a stroke if transferred to Viennese soil. This has nothing to do with the power of habit. Because there are quite specific reasons why Danzig is a city of bare brickwork and Vienna one of lime plaster.

I do not want to discuss the reasons here, since the proof would fill a whole book. Not only material, but architectural forms are bound to place, to soil and air. Danzig has high, steep roofs. The architectural solution of these roofs required all the inventive energy of the architects of Danzig. Vienna is different. Vienna has roofs as well. But our architects have ignored the roof. If you

are still in the street on Midsummer's Night, and the roofs stretch out before you, you imagine you are walking through a new city. We no longer need to take heed of passers-by, carriages and automobiles, and we are astonished by a wealth of details that the day has withheld from us. And then we see the roofs of Vienna, we see them for the first time, and wonder how we could have overlooked them by day.

But Viennese architects left the roof entirely to the carpenter. The work was complete with the entablature. Palaces were given a parapet wall with vases and figures on it. The solid citizen forswore this.

Five minutes from Vienna, after crossing the glacis of today's Ring, there was 'the roof'. The same architects who did not design roofs in Vienna were full of spirit and invention when it came to the roofs and domes of a house or palace in the suburbs. I mention this only to prove that the old Viennese architects took the architectural character of a place into their calculations and avoided anything that might disturb it.

I accuse our contemporary architects of deliberately failing to take the character of buildings

into account. But the architecture on the Ring-strasse has adapted itself to the city. However, if the Ringstrasse were built today, we would have not a Ringstrasse but an architectural catastrophe.

If I look from the Opera towards Schwarzen-bergplatz, I am filled with the feeling: Ringstrasse! The feeling: Vienna! But on the Stubenring I have the feeling: five-storey Mährisch-Ostrau.

Are the buildings on the Stubenring bad? Or those on the Kärntnerring good? Neither is the case. There are good and bad buildings in both places, buildings by artists and frauds. But artists and frauds on the Kärntnerring have taken the character of the buildings in Vienna into account, while on the Stubenring neither gave it a thought.

Typically Viennese is the straight wall end, without roofs, domes, oriels or other structures. The building law specifies a height of 25 metres to the upper edge of the parapet. But the roof should be exploited and contain studios and other rentable rooms. Because the property costs a lot of money and taxes are high. And for financial reasons the old character of the Viennese

buildings was lost. I think I know one way in which we can get it back. Certainly not with new laws, which would take rights away from the owner of the house and the land. Certainly not according to the popular principle: equal injustice for all. But: anyone who undertakes to construct nothing, absolutely nothing, above his parapet shall be authorized to build six storeys. For sooner an honestly tall building than one with roof monstrosities built in the so-called enfeoffment style. Then we would once again have beautiful monumental lines and grand proportions, we, who have basked for centuries in the Italian air that comes over the Alps, in Italian grandeur and monumentality, things that are in our blood, and for which people in Danzig can rightly envy us.

And then we have lime plaster. We look down our noses at it, and in a materialistic age have begun to be ashamed of it. Good old Viennese plaster is mistreated and prostituted, it is no longer allowed to remain who and what it is, and it is used to imitate stone. Because stone is expensive, and it is cheap. But there are no expensive and cheap materials in the world.

Here the air is cheap and on the moon it is expensive. To God and the artist all materials are equal and valuable. I am in favour of people considering the world with divine and artistic eyes.

Lime plaster is a skin. Stone is constructive. In spite of their similar chemical composition, the greatest difference between them lies in their artistic use. Lime plaster has more in common with leather, wallpaper, wall fabrics and lacquer paints than with its cousin, limestone. If lime plaster presents itself honestly as a coating for brickwork, it should not be any more ashamed of its simple origins than a Tyrolean with lederhosen and bare knees in the Kaiserburg. But put tails and a white cummerbund on both, the man will feel insecure there, and the lime plaster will suddenly become aware that it is a fraudster.

The Kaiserburg! Its proximity alone is a touchstone for authenticity and inauthenticity. I always give a piece of good advice to people with uncertain taste. If you want to know whether an object is good or bad, ask yourself: would this object suit the Burg or not? That is the test of fire. Apparently tasteful objects such as the products of the Copenhagen porcelain industry,

Galees glasses and the work of the Wiener Werk-
stätte cannot pass this test, while the greatest
monstrosities of taste, such as waiting Dober-
manns painted on metal, which are used for fire
tongs and pokers, may survive. But the metal
Pintscher is right, and the Copenhagen cat[21] is
wrong.

And near the Kaiserburg there was the task
of erecting a new building, modern business
premises. It was a matter of creating a transition
from the imperial residence via the palace of a
feudal lord to the most elegant shopping street,
the Kohlmarkt. The construction site, which
was established at the time by Professor May-
reder and the current director of the municipal
planning office, Oberbaurat Goldemund, has
been enlarged. Certainly not to the benefit of
the square. They have attempted to compensate
for this error with a large colonnade of Cipol-
lino monoliths, which sets the façade three and
a half metres back on the ground floor and the
mezzanine. It was supposed to be a kind of bour-
geois house: the architectural design stops at the
parapet, and the copper roof, which will soon
have turned black, will never be noticed by

Midsummer Night's Dreamers. And the four floors are to be covered with lime plaster. What is necessary for decoration should be honestly applied by hand, a rule with which our old Baroque masters complied in those happy times when there were no building laws because everyone carried the law in their heart.

But on the ground floor and the mezzanine, where the places of business open up, modern business life demands a modern solution. And rightly. For modern businesses, the old masters could leave us no models. And not for electric lights, either. But were they to rise from their graves, they would find the solution soon enough. Not in the spirit of the so-called modern age. And not in the spirit of the archaizing paperhangers who stick porcelain candles with lightbulbs on old candle-holders. But new, and very differently from the thinking of these two opposing camps.

An attempt was made to harmonize the building with the imperial palace, the square, the city. If this attempt succeeds, Baurat Greil will win gratitude for finding a truly elegant interpretation and alternative to a rigid law.

RULES FOR THOSE BUILDING
IN THE MOUNTAINS (1913)

Don't build picturesquely. Leave such effects to the cliffs, the mountains and the sun. A person who dresses picturesquely is not picturesque but a buffoon. A farmer doesn't dress picturesquely. But he is.

Build as well as you can. Not better. Don't strain yourself. And not worse. Don't deliberately bring yourself down to a lower level than the one on which your birth and upbringing have placed you. Even if you are going into the mountains. Talk to the farmers in your language. The Viennese lawyer who talks to farmers in a hayseed dialect must be eradicated.

Pay attention to the forms in which the farmer builds. Because they are ancestral wisdom, substance solidified. But seek out the reason behind

the form. If technological advances have made it possible to improve the form, then that improvement should always be used. The threshing flail is superseded by the threshing machine.

The plain requires a vertical construction; the mountains a horizontal one. Human work must not compete with the work of God. The Habsburg-warte[22] disturbs the range of the Vienna Woods, but the Hussars' Temple[23] fits in harmoniously.

Don't think about the roof, but instead about rain and snow. That's how the farmer thinks – so in the mountains he builds the flattest roof possible, according to his technical experience. In the mountains the snow mustn't slide off when *it* wants to, but when the farmer wants it to. So he must be able to climb on to the roof to clear the snow away without putting his life in danger. We too have to make the flattest roof possible with *our* technical experience.

Be truthful! Nature can only bear truth. It can easily cope with iron lattice bridges, but it abhors gothic arches with bridge-towers and loopholes.

Don't be afraid of being rebuked for being unmodern. Changes to the old building style are only allowed when they constitute an improvement. Otherwise stick to the old. Because the truth, even if it is hundreds of years old, has more internal connections with us than the lie that walks beside us.

HANDS OFF! (1917)

Believe me, I was young once too. As young as the members of the German Association of Craftsmen, the Austrian Association of Craftsmen, the etc., etc. I too, when I was still a boy, liked the beautiful ornaments that decorated our household, I too was intoxicated by the word *Kunstgewerbe* [craft] – the term in those days for what we yesterday called *angewandte Kunst* [applied art] and today call *Werkkunst* [artwork] – and I too felt deep sadness when I looked down my body to my feet and could discover in my coat, my waistcoat, my trousers and my shoes nothing at all in the way of art, whether craft-based art, applied art or any art at all.

But I grew older, and in my adolescence it struck me that in former times the coat had harmonized with the wardrobe. Then both had ornaments, both demonstrated the same artistic

practice, and so all that remained to me was to think about who was right – today's ornament-free coat or today's wardrobe with the traditional ornaments of Renaissance, Rococo or Empire style. We agreed. That both the coat and the wardrobe should correspond to the spirit of our time. I and the others. But I bade farewell to my boyhood dreams, while the others remained true to them. I opted for the coat. I said the coat was right. I thought that it and not the wardrobe was made in the spirit of our time. It had no ornaments. Fine – it was hard for me to think that way, but I thought it through – our age has no ornaments. What, no ornaments? When ornaments sprouted and blossomed from *Jugendstil*, from *Deutsche Kunst und Dekoration*, *Dekorative Kunst*, etc.? And I thought the matter through again and again, however much it hurt, I thought that these newly discovered ornaments had less to do with our time than the false imitation of old styles. I thought that they were nothing but the morbid ravings of individuals who had unhappily lost contact with the age; in short, I thought what I set out in my lecture 'Ornament and Crime'.

So once again: the suit I wear is really made in the spirit of our time, and I will believe in it until my dying day, even if I am the only person in the world with such a belief. But I also found many other objects which demonstrate this spirit of our age. There were shoes and boots, suitcases and horse-harnesses, cigarette cases and clocks, pearl necklaces and rings, sticks and umbrellas, cars and visiting cards. And at the same time the works of our craft, which reveal a quite different spirit.

I tried to find the reason for this diametrical opposition. I found it easily. All – for me – untimely works were made by craftsmen who had become dependent on artists and architects, while the works that were timely were made by craftsmen to whom the architect delivered no designs.

For me the principle applied: if you want to have a contemporary craft, if you want to have contemporary utility objects, poison the architects.

In those days, now twenty years ago, I was prudent in not voicing this suggestion. I was cowardly and feared the consequences. So I took another path. I said to myself: I want to teach the

carpenter to work as if no architect had ever blundered into his workshop.

That was more easily said than done. It was as if a man were to invent our modern men's clothing after everyone had been walking around in Greek, Burgundian, Egyptian or Rococo costume for a whole century, as if for a masked ball. But when I considered the tailor's profession, I could say to myself: a hundred years have not brought so many revolutions with them. A hundred years ago one wore blue tails with gold buttons; today one wears black tails with black buttons. Should carpentry really be any different?

I thought: perhaps these wretched architects have also left behind something in carpentry that might be connected with the contemporary, perhaps something in carpenters' workshops has escaped their loathsome hands and has without their help taken the calm route of development? I thought this when I woke up and when I went to sleep, when I ate and drank, when I went for a walk, in short, always and everywhere. Then my eye fell upon the good old water tank with its wooden cladding, which forms the back wall of the water closet in the old system.

What joy! All other objects that serve to cleanse us, the bath and the wash basin, in short all sanitary articles, have been spared by 'artists'. There were probably various articles under the bed that were decorated by artists' hands with Rococo ornaments, but they were rare. And so that single piece of carpentry – by virtue of not being noble enough – had escaped 'applied art'.

What was the essential aspect of this wooden cladding? I must ask to be able to say a few words about carpentry technique. The carpenter can in different ways bring together pieces of wood to form a plane. One of them is the system: frame and filling. Between the frame and the filling a profiled block of wood was inserted as a transition, or else the frame, since the filling was almost always recessed, was given a profile, a concave shape. Very abruptly the filling lay half a centimetre behind the frame. That was all. A hundred years ago it had been exactly the same. Now I knew for certain that nothing in this form had changed, and that all experiments with which the Vienna Secession and the Modern Belgian School had suddenly assailed us were aberrations.

The place of the fantastical forms of previous

centuries, the place of the blossoming ornamentation of earlier times, had therefore to be occupied by pure, clean construction. Straight lines, right angles: that is how the craftsman works, who has nothing but his purpose before his eyes, and material and tools.

A colleague (he is today a leading Viennese architect) once said to me: 'Your ideas might apply to cheap work. But what do you do when you have to furnish a home for a millionaire?' From his perspective he was correct. Fantastical form, ornamentation was the most precious thing anyone was familiar with. We still knew nothing about the true differences in quality. But among craftsmen who had been left alone by architects they had always existed. No one was surprised that for a pair of shoes one might pay ten crowns from one cobbler, and fifty from another, even though both were made from the same 'drawing' in the shoemaker's journal. But woe betide the carpenter who asked 50 per cent more than his competitor in his tender! They would not be distinguished according to material and work, and the expensive man, who claimed to deliver the better work, was marked out as a con man.

So this good workman gave up and delivered work as bad as everyone else's. That too we owe to artists.

Bear in mind that noble material and good work do not merely compensate for a lack of ornament but are far superior to it in terms of exquisiteness. Indeed, they exclude ornament, because today even the most decadent of people would be reluctant to decorate a noble wooden surface with inlay, engrave the strange natural play of a marble panel or cut a wonderful silver fox into small squares to assemble a chessboard pattern with different furs. Past ages did not value material as we do today. Then one could easily – and without a guilty conscience – ornament. We have swapped more glorious things for the ornamentation of earlier periods. *A fine material is a miracle of God.* I would gladly give all the works of Lalique or all the jewellery of the Wiener Werkstätte for a precious pearl necklace.

But what does the 'artist', sitting at the drawing board, know of the fanatical obsession of the pearl trader who spends years of his life assembling a pearl necklace, or the deep needs of the carpenter, who has found a noble piece of wood

and now wants to make a particular work from it?!

In 1898 all wood was stained green, blue or purple – the architect had a paint-box at his disposal – and it was only when I first used mahogany in a modern work in my Café Museum in Vienna that the Viennese noticed that there were not just fantastical forms and colours, but also different materials.

And different ways of working. Because I knew this and heeded it, simple items of furniture which I made twenty years ago still live today and are in use (such as a dining room in Buch near Aarau). The fantastical products of the Secession and Jugendstil of those days are gone and forgotten.

Material and work have the right not to be devalued every year by new trends in fashion.

LEARN A NEW WAY OF DWELLING! (1921)

The new movement that has afflicted all the inhabitants of this city like a fever, the *estate movement*, demands new people. People who, as Leberecht Migge, the great landscape architect, so rightly says, have modern nerves.

It is easy for us to describe a human being with modern nerves. We do not need to strain our imagination. They are already living in a state of exhaustion, not in Austria, but a little further west. Our descendants are the ones who will receive the nerves that Americans have today.

The city-dweller and the farmer are not so sharply divided in America as they are hereabouts. Every farmer is half a city-dweller, every city-dweller half a farmer. The American urbanite has not distanced himself as much from nature as his European colleague, or rather his

continental colleague. Because the Englishman is also a proper farmer.

Both – English and Americans – feel living with other people under one roof to be a disagreeable condition. Everyone, rich or poor, strives for his own home, even if it is only a cottage, a dilapidated shack with a drooping thatch. And in the city they do a spot of play-acting and build revenue houses[24] whose individual apartments are arranged on two floors, connected by special wooden stairs. Cottages placed on top of one another.

And this brings me to the first item on my agenda. A person in his own home lives on two floors. He divides his life sharply into two parts. The daytime and the night-time parts. Dwelling and sleeping. One should not imagine that life on two floors is comfortable. On our terms it certainly isn't. They are two small and unhomely for that. The only item of furniture is the white-painted iron or brass bed. One would seek in vain for so much as a bedside table. And there are no wardrobes either. The 'closet', the wall cupboard, literally the 'closure', takes the place of the cupboards. The purpose of these bedrooms is

really only to sleep. They are easy to tidy. But they have one advantage over our bedrooms, which is that they have only one entrance and can never be used as walk-through rooms. In the morning all the family members come downstairs at the same time. Even the baby is brought downstairs and spends the day with its mother in the living areas.

In every family there is a table around which the whole family can gather at meal times. Like farmers, then. Because in Vienna only 20 per cent of this city does that. What do the other 80 per cent do? Well, one sits by the stove, one holds a pot in their hand, three at the table, the others occupy the window sills.

And now every family that gets its own home is to receive a table which is, like the farmer's table, in the corner of the sitting room. As in a peasant house. That will make for a fine revolution! One hears voices for and against. 'Well, well, we're not doing that. I've seen that among the farmers in Upper Austria. They sit at a table and all eat from the same bowl. And, well, we're not used to that kind of thing. We sit individually.' And a concerned father said: 'What, around one

table? My children will be getting used to going to pubs!'

And when I tell that story, people laugh. But I weep inwardly.

We won't argue over the table. It soon becomes clear that communal breakfasting saves money. The Viennese breakfast – a gulp of coffee standing by the stove and the piece of bread consumed half on the stairs, the other half in the street – demands a goulash at ten o'clock, a way of cheating the stomach, and since the goulash is nicely peppered with paprika, a little mug of beer. This meal, for which the English and the Americans do not even have a name, is known to us as *Gabelfrühstück* – 'fork breakfast' – plainly because only the knife comes into play. Admittedly one is not supposed to eat with one's knife – 'but what are we going to eat the sauce with afterwards?'

May the father of the house be granted this second breakfast for as long as he must settle for his gulp of black coffee at home. But his wife will soon work out that for the same money the whole family can have a wonderful American breakfast feast, so filling that one can eat nothing till

midday. In the American family breakfast is the finest meal. Everyone is refreshed by sleep; the room is comfortable, freshly aired and warm. The whole table is laid with food. First of all everyone eats an apple. And then the mother serves the *oatmeal*, that wonderful food to which America owes its energetic people, its greatness and its welfare. The Viennese, however, will pull long faces when I reveal to them that *oat* means the grain and *meal* means food. But in Lainz[25] we will offer trippers porridge prepared in the American style and hope to convert the whole of Vienna to porridge-eating. What use to us are the beautiful oat-fed horses that we are so proud of? Humans too should have 'well-contoured' heads, expressive faces.

Whether rich or poor, farmer or billionaire, porridge appears on every breakfast table. Everything else, cheap fish or expensive veal cutlet, depends on circumstances. Of course there is tea and bread, which is curiously also served at midday and in the evening.

Lunch is a very simple matter. The father is not at home, the mother has been busy tidying the house all morning. Because the housewife

does not have a servant. And the lack of a helpful genie of the house means that food is prepared in the sitting room. Because the woman of the house is entitled to spend her time not in the kitchen but in the sitting room.

But that arrangement means that cooking is divided into two. The work is divided into two distinctly separate parts. One part is the work over the fire, the work at the stove. The other part is the preparation and the washing-up. The first part is carried out in the living room, where the stove is located. For this, however, it is necessary for the stove to be hidden as much as possible from the eye of the resident.

All the things they have come up with in America to solve this problem! Only recently I saw a photograph, or rather two photographs, in a magazine. One picture showed a stove lodged in a niche in the wall, the second a desk. It was the same niche in the wall: a push of a button and, as if in a tabernacle, the mechanism, driven by electricity, rotates according to requirement.

But such an arrangement requires more than technology can produce. It requires people who aren't afraid of cooking. We, who all have a slight

dread of cooking, a feeling that farmers, the English and the Americans do not possess, are amazed that these exotic creatures are offered dining rooms in which food is cooked in front of the dining guests. During the war this room was called the roast room, now it is once again called the grill room. But the simple settler will call it a living kitchen or a cooking room and will feel as aristocratic as an English lord. Or as vulgar as an Austrian farmer.

Anyone who wishes to settle must relearn. We must forget urban revenue houses. If we want to go to the country, we must go to school at the farmer's house and see how he does it. We must learn a new way of dwelling.

ARNOLD SCHÖNBERG AND HIS CONTEMPORARIES (1924)

The *Gurrelieder* – the most recent compositions! What do you make of them? And if Schönberg really wishes to defend the last few years of his work – and of this there can be no doubt – what is his position on the *Gurrelieder*? Is he not bound to repudiate them? And yet in fact we learn the opposite: we have seen that he himself has rehearsed and conducted them. Explain that contradiction to us!

My honoured audience, you are mistaken. No one repudiates what he has made. Neither the craftsman nor the artist. Neither the cobbler nor the musician. The differences in form that the public perceives are hidden from the person who makes them. The shoes that the master shoemaker made ten years ago were good shoes. Why should he be ashamed of them? Why should he repudiate them? 'Look at the rubbish I made ten

years ago' – only an architect could have uttered those words. But, as everyone knows, I don't count architects as human beings.

The craftsman creates form unconsciously. The form is accepted by tradition and the changes that occur during the craftsman's life are not dependent on his will. His clients, who change – they grow older – give him the stimulus, and so they effect a change of which neither the consumer nor the producer is aware. In his twilight years the master shoemaker makes different shoes from the ones he made in his youth. Just as his handwriting has become different over forty years. As all handwriting changes to the same degree, all writers are involved in this change to the same degree, so that one can easily guess the century from the shape of the letters.

The artist is different. He has no client. The person who gives him his commission is himself.

His first work will always be the product of his milieu and his will. But for anyone with ears to hear and eyes to see, this first work contains the whole of the artist's life's work.

Crocodiles see a human embryo and say: 'It's

a crocodile'. Humans see the same embryo and say: 'It's a human being.'

Crocodiles say the *Gurrelieder* is Richard Wagner. But humans feel something unimaginably new after the first three bars and say: 'That's Arnold Schönberg!'

It has always been so. Every artist's life has been subjected to this misunderstanding. His distinctive qualities remain unknown to his contemporaries. He probably feels that the mystery is something alien, and at first he relies on analogies. But when he becomes fully aware of the new, the artist's ego, he attempts to salvage his own inferiority with laughter and rage. We know Rembrandt's work from his earliest boyhood. He was a famous painter. Then he made *The Night Watch*. People ranted and raged: 'Why is he working differently?' 'This isn't the famous Rembrandt, this is a ghastly mess!' And the master was surprised and didn't know what the public meant. He didn't see what the public saw. He hasn't changed at all, he has done nothing new. Three hundred years on, the public agrees with the master.

He really wasn't a new Rembrandt, but a

better, bigger, more powerful one. And the public looking through Rembrandt's work cannot see the rupture that was so keenly identified by the master's contemporaries. Even the boyhood drawings contain the whole of Rembrandt, and we wonder with astonishment how it was possible that the revolutionary aspect of these paintings was accepted with so little resistance. But people saw only the crocodile.

Should I suggest other examples? Beethoven's journey? Have we forgotten that the Ninth Symphony was excused by referring to the master's deafness? That his work might have been lost to us for ever had the French not stepped in on behalf of the now deranged German master?

Centuries may have to pass before people wonder what it was that made Arnold Schönberg's contemporaries get themselves into such a state.

ON THRIFT (1924)

A cause becomes unmodern at the moment when our feelings revolt, and as soon as we feel ourselves becoming ridiculous, we want to return to the cause.

The top hat has various shapes. Let us put a hundred top hats side by side. I want to go to a funeral. I try on various styles, I see that they are mostly impossible, ridiculous, and that only one hat is suitable. The one, let us say, from 1924.

This top hat is the only possible cause for me and my time.

People only find things modern if they are possible in the first place.

The top hat of 1924 is entirely possible, and if I could have worn it twenty years ago and could wear it even today, everything would be excellent. And because I can wear it at all, this top hat is fully justified in terms of production,

or more generally speaking, in commercial terms.

But these are all in fact matters of fashion, which soon pass.

But if it happens that a desk loses its aesthetic value for me after ten years, that I find it impossible, that I remove it and must buy myself a new one, it is an enormous economic loss.

I reject all addiction to innovation. Only a conservative person is thrifty, and every innovator is a spendthrift. But a person who has many clothes is keen to ensure that they do not fall out of fashion.

A person with only one suit is not bound to caution. On the contrary. In a very short time he has destroyed his suit with constant use and thus forces the tailor to invent constantly new forms.

The objection that these constant changes in fashion are a very useful thing in that they create a great deal of work for the producers is a mistaken view.

One must have many clothes so that one can change them according to actual need. In the rain I take my rubber raincoat, in the spring I put on an overcoat, in winter a woollen suit and thus I

spare my whole wardrobe. Fashion is something that changes quickly only because we cannot manage with our things over time. As soon as we have objects that survive for a long time and stay beautiful, fashion immediately stops. We have to measure beauty according to time. I cannot judge railway lines according to how many trains can travel over them, but only according to their durability. They will always be good if they offer good and reliable service.

Material lives. And material, fabric, product, clothing necessarily require a certain period of molecular repose.

So I praise large wardrobes, that is the correct method, because amongst other things such a wardrobe reassures me with every minute of my independence.

Changing style where actual improvement is possible – it is the greatest nonsense.

I can invent something new where I have a new task, in architecture, for example: a building for turbines, hangars for airships. But chair, table, wardrobe? I will never admit that we should change forms that have been tested and settled into over centuries because of some imaginative need.

The difference between the eighteenth and nineteenth centuries is effectively an abyss. In those days 95 per cent of all people worked so that 5 per cent could wear wigs and expensive clothing and present themselves as cavaliers. That was a great social immorality.

Today the worker and the English king, from the stylistic point of view, wear fundamentally the same clothes. Our presidents and monarchs in the twentieth century do not have the slightest need for mummery with crowns and ermine cloaks.

This has a deeper meaning than it might seem to have. The intelligent modern person must have a mask for other people. That mask is the particular form of clothes common to everyone. Only mentally limited people have individual clothes. They have the need to proclaim to all and sundry what they are and what they are actually like.

And it is the same with furniture. One has formally random objects made so that one notices immediately which lord and master owns them, and that as a human being he is quite different from all other people.

It is true that there are cheap and expensive

clothes. That depends upon the quality of the fabric and the excellence of the work. But here too there are boundaries. In sport we have champions who can run 100 yards in the shortest time imaginable. There is a person who jumps highest of all people. And similarly somewhere there is an excellent tailor who can make the most technically perfect clothes from the best material. He may be in New York, in London, in Paris, I don't know where.

Luxury is a very necessary thing. Someone must pay for quality work. And this luxury industry, which serves only a few, means what I have said about the best runner and the most excellent jumper, that is, that at least a small handful of skilled people must struggle to attain this perfection of production. With talent and endurance. That must be an example of the best human abilities. Otherwise things go downhill with everything and in every field. The tailor to the English king has an effect through his encouraging example, through his perfect work on the whole of English clothes production. Without these excellent people we cannot go beyond the average.

Every effort to reduce the durability of an object is mistaken. In all the objects that we produce we must increase their durability over time. Then it is correct.

I have a fabric that is bad, I have a suit made, and the fit lasts a third as long as a good one does. One to three! A good suit means thrift, a bad one means a waste of money. That is a large and extraordinarily significant economic question.

But if things are produced in the best material and by the best technical staff, objects of so-called craft, which fall out of fashion in a few years because of their eccentric form – that is waste.

Working away for months with lace shuttles just so that the lace can be torn in a single night is a bad thing. Those laces are produced effortlessly and disproportionately more cheaply by machines.

Let us seek refinement and economy. I don't know who is more thrifty: someone who drinks good wine or someone who drinks large quantities of bad wine.

But I also want to say something about the psychology of saving. If I buy a cigarette-case, I

don't want to be hoaxed, I don't want someone to take away my delight in material and labour and give me the doubtful pleasure of ornament. I want the material itself in a purposeful finish. A ring is a piece of good gold in hoop form. A cigarette case is two shallow bowls of good silver, quite smooth. The beautiful smoothness of the silver surface, so pleasing to the touch, is the best decoration.

But people don't like that. They want something complicated, something effortful. Which means African conditions in our country. The Middle Ages!

All this effort and complication! How can I enjoy a meal if it has been prepared with great effort and the application of a great deal of ingenuity over a whole week: all that effort, complication and excessive care will only make the meal tasteless and stale. Just because it has been worked on for a week. Modern man finds it hard to bear such excesses of energy.

How can I delight in an object which has been worked on for five years? That is gentlemanly sadism. These days we are simply above such things. On the contrary, we want to save on

work, spare our fellow man and above all economize on material. I admit that I am almost pathologically thrifty, and would like to be a leading saver.

If I see a lopped board, I feel sorry for the material because I complete the missing piece by imagining the part in the empty spot. And I feel sorry for the piece.

In Prague I have seen noble material being mercilessly cut and turned into lathed and complicatedly assembled objects. That is a sin.

Every era is thrifty in its way. The eighteenth century spent a great deal on food and saved a lot on cleanliness. It is a stinking century. You can even smell it in its furniture.

Today more attention is paid to cleanliness.

American soldiers set up bathrooms for themselves even in the trenches. And what happened? People exclaimed: 'Are they supposed to be soldiers?' Why? Because here in Europe the idea of the soldier is inseparably linked with an unclean soldier.

And, again, everyone saves differently on different things.

I am convinced that the proletarian is a much

less thrifty person, that he spends money much more easily. The worker does not think for long about whether he should drink a glass of beer; the official thinks long and hard, but the same official thoughtlessly throws money at a stupidly decorative tie, about whose purchase the worker would need to think for at least half a day.

The former love of ornament must be replaced by a pleasure in material. We don't know material at all. Once upon a time gold ducats were thrown out of the window – a lordly diversion – and pearls were dissolved in vinegar, and the solution was drunk. Pearls were also carved. No one would do such a sinful thing today.

And we have the least feeling for material; the least respect for substance is to be found in cabinet-making. Modern architects have eliminated this feeling for material in architecture and cabinet-making.

A Chinese man was given a task; he went into the forest and looked for a suitable tree. He looked for a long time; in the end he found it and said, 'If I had not found the tree, I would not have carried out my work.'

That is how to have feeling for material!

Material must be deified again. Materials are nothing less than mysterious substances. We should be deeply and reverentially astonished that anything of the kind was ever made.

And decorating a perfectly beautiful material with ornaments? 'Improving' fine mahogany with a purple stain? Those are crimes.

Someone tells me it is a cruel punishment to be sentenced to such an ordinary prison, pleasant because of its very simplicity, because of the language of the whitewashed walls, the plank bed. If so, I can't think how much more terrible prison in a very contemporary interior made by a 'modern architect' would be, from carpets to curtains, from the ashtray to the clock-hand and from the coal-scuttle to the fountain pen.

Ten years' imprisonment for such a designer!

Our architects – furniture designers and decorators – see their main task as outdoing. Please, I repeat: outdoing. The shoemaker who makes good shoes can never outdo those good shoes of his. And if I know how to look after his products, because I have a lot of shoes, they will always be modern. Shoemakers don't outstrip one another, thank God. And God forbid that

architects should make shoes. Then shoemakers would be outdoing one another at least every two years.

I have had shoes for twenty years and they have not fallen out of fashion.

I don't need to draw my designs. Good architecture, how something should be built, can be written. The Parthenon cannot be written down.

I am opposed to taking photographs of interiors. Something else always comes out. There are architects who furnish rooms not so that human beings can live comfortably in them, but so that they look good in photographs. They are the so-called architectures on paper which, with their mechanical composition of lines of light and shade, correspond more appropriately to a mechanical apparatus, in this instance the dark room. I cannot judge the furnishing of my apartment on the basis of photographs or reproductions. I am sure that in a photograph it would look wretched and ineffectual.

Photography dematerializes, in fact, but what I want is for people to feel the material in my rooms, I want it to have an effect on them, I want them to know about the closed space, to feel the

material, the wood, to perceive with their sense of vision and their sense of touch, sensually; in short, to be able to sit carefully and feel the chair on a big area of their peripheral physical sense of touch and say: this is a place where one can sit perfectly. How should I prove to the person who sees this photograph, prove so that he can judge how well one sits on my chair, however it is photographed?

So you can see, photography says nothing. Photography draws little pictures that are pretty or not so pretty. These distract people from the most authentic thing. Bad manners. It is on photography's conscience that people want to furnish their homes not in order to live well but so that things look pretty. Photography deceives. I have never wanted to deceive anyone with my things. I reject such a method. But our architects are only brought up in this method of deception, and grow from it; they base their reputation on pretty drawings and beautiful photographs. They do it deliberately, because they know that people are so perplexed that a drawn, photographic illusion is enough to live in and even to be proud of. And the customers are so dishonest

with themselves that they refuse to admit to themselves that they are living with self-denial in all these drawings and photographs.

- Folk art? What is that? Bare knees? National costumes?
- Folk dancing? And those of us who live in the city are expected to go there as if going to the theatre, sit on benches and watch? Is that not so much fiddle-faddle? Is that not as shaming for us as it is for the country people? Do we city-dwellers and the people in the country need such a thing?

The barriers between country and city in general should fall. This difference is both artificial and ridiculous. We see the people from the country as primitive people. They are ridiculous to us city-dwellers. We are ridiculous to the country-dwellers. It's an artificial barrier of which we should be ashamed: the lack of understanding of the fundamental functions of life, the lack of understanding of people's work, of the higher vocation that every working person has, whatever useful thing he does, wherever he lives, in

Paris or some remote Moravian village. Two such people may have their significant quality, because the Moravian may be good for nothing as a human being and the Parisian may be a complete dunderhead, or one of them is something and the other nothing – the circumstance that someone lives in a particular place on the globe, does this work or that, still does not in any way define his humanity. Only a limited person from Prague or Vienna could imagine that they were something more than someone who lives and works in Iglau or Lhota. I am always glad when I have lived for a long period in America and England.

The English bride would most like to take away all her parents' furniture. In our own country brides do not want to hear that they would ease their parents' financial burden by taking some of their furniture. They want to have something new, 'fashionable', 'modern'. They even want to have an 'artistic design'. And in four years they will want another 'artistic design', because they will find that their furniture is entirely unmodern, and very new artistic designs are being made. That's terrible! It's a

waste of energy, work, money; this does terrible economic damage.

At the same time, English furniture is the apogee of comfort, and ours – 'from artistic designs of modern architects' – a pyramid of nonsense and sins against material, purpose and treatment.

An English club armchair is an absolutely perfect thing. In England and America such perfect models exist in other genres of furniture. I think that every year all around the world only one good model is made that is capable of a long existence. Everything else disappears in a few years, it becomes unbearable to people like an old lady's hat. The so-called decorative arts create entirely broken-backed things, and such 'artistic furnishings' can only exist because they are ordered in advance and paid for in advance, because they have been produced before, because they stand in the apartment in a single set, and people must patiently endure them whether they want to or not – if they have got into similar trouble in the past.

So I don't like it when people call me an architect. My name is simply Adolf Loos.

The Viennese think saving is a truly terrible thing. It is a real mania, how they must constantly change their apartment, constantly buy or rearrange things, run from architect to architect. This chaos is a sign of our time. And anyone who contributes to a bit of peace in our architecture will render a service.

We have no architecture, we have houses that are dressed. It's like saying: not a saddle, but a dressed saddle. That is a saddle that has an ornamental form, and whose purpose becomes apparent either not at all or quite inadequately beneath an applied-art dress, as a woman's body is hidden in an applied-artist dress 'from a design'. We must dress ourselves, but why we dress our architecture I don't understand.

If the Ringstrasse had not been built in the 1870s and were being built today, we would have a complete architectural catastrophe. I want only one thing from the architect: that he show decorum in his building.

On all the occasions when I have been in Brno and seen the Deutsche Haus and the Czech 'Beseda', the character of these two buildings immediately told me what would eventually have to happen in

Brno. I would like to be able to reproduce these two pictures side by side somewhere. But after what I recently saw in Prague, I think the Czech architects have been converted to the forms of the Deutsche Haus in Brno. That is a bad sign.

One millimetre more or less in the profile – that causes me pain. The present-day architect is by both attitude and upbringing an unthrifty person. And of those involved in theatre decoration we may expect nothing sensible. They are people for whom not saving on material has become a long-standing habit. They become specialists in cardboard rocks, in all kinds of tricks and illusions, and completely lose their sense of dimension because it is the only way in the theatre: everything is temporary, to be looked at. Theatre directors have invited me to performances of plays. I didn't go. It contradicts my entire nature. I find theatrical props entirely unbearable. They aren't architecture.

You can most easily tell if something is modern or not by whether it looks suitable in the vicinity of old things. I assure you that my furniture fits in the vicinity of European furniture of all centuries and all countries and no less well with

Chinese, Japanese and Indian objects. Try something similar with the creations of our 'applied art'.

The first thing of all in a room is the chair. If I am to furnish something, I first of all need a chair, and from there I move on to everything else.

I consider it a great mistake when people buy furniture made from fine woods and precious materials. Then they must always take care that nothing is damaged. For real living we have materials for all eternity, and they would be none other than pig's leather, oak, wool.

The apartment must never be finished. Is a human being ever concluded, finished in a physical and mental respect? Does he stop at a dead point? And if the human being is in constant motion and development, if old needs pass and new ones come into being, if the whole of nature and everything around us changes, should the thing closest to the human being, his apartment, remain unchanged, dead and furnished for all times? No. It is ridiculous to prescribe to people where a thing should stand, arrange everything for them from the bathroom to the ashtray. On the contrary, I like it when people organize the furniture around them as they (not I!) need it,

and it is entirely natural, and I approve when they bring in their old paintings, their memories that they love, whether the things are tasteful or tasteless. That bothers me little. But for them it is a piece of sensitive life and familiar intimacy. That means that I am an architect who designs interiors humanely and not artistically and inhumanely. It amazes me that so many people allow themselves to be tyrannized by so-called interior architects.

At the academies our architects are taught the lesson: 'How beautiful it once was – and how unsuitable it is now.' I was taught it myself. And it was years before I violently forced myself to abandon those impossible views, re-educated myself and understood that it is in fact the aristocrat who can serve us as a model in one respect. I mean that he has a sense of material. Not horses as such, or beautiful horses, but thoroughbred if less attractive horses. Not just any suitcase, but one made from the very best material. A sound one for whole centuries. And so I came to understand that the fundamental principle that guides many otherwise intellectually limited members of the jockey-club is entirely correct. Aristocrats

paid heed only to the material and the precise and perfect work. That was a difficult process for me. Why? Because it was considered shameful to say that it was correct. Incidentally, this is all down to Ruskin. I am his sworn enemy. It was not until some point in 1895, when I was in America, that I understood that a Thonet chair is the most modern chair.

Any joiner can make the objects that I use in my interior design. I am not making myself a patent architect. Any marbler, any textile maker or industrialist can make my things and doesn't need to ask me respectfully. The main thing is that he does an honest job. And I have not guarded against anything as much in my life as the production of new forms.

Architects are there to grasp the depth of life, think through to its most far-reaching consequences the need to help those who are socially weaker, to equip as large a number of households as possible with perfect utility objects, and architects are never there to invent new styles.

But these are all views which, even in Europe today, will be understood by as many people as could be counted on the fingers of one hand.

EPILOGUE
CRITIQUE OF ORNAMENT

Joseph Masheck

So much of the discourse on Adolf Loos concerns his theoretical standing as one of the founders of architectural modernism by virtue of his active opposition to ornament, that, for many, the Loos of negative polemic is so exclusively the object of concern that they never come face to face with his work at all. Is there any modern painter or sculptor so badly off as to audience? Possibly John Cage in music; and pursuing solely his reputation, without artistic engagement with any works or performances, must also lead back to the same mistaken conception – ultimately dismissive of just what we are looking for, i.e. art – of Loos as merely the Marcel Duchamp of architecture. Then again, some people listen to Cage, and many people actually look at Duchamp's readymades.

Giving Loos more of a chance as artist-architect also gives good reason for fresh reading

of his two most important and problematic texts: 'Ornament and Crime' and 'Architecture', which, ironically, require and deserve more textual attention than they usually receive – ironically because part of the problem has been a too visually oblivious, especially form-oblivious, approach to Loos, and yet his prime written texts nevertheless suffer from not being taken seriously enough as problematically textual: Loos has been approached in an overly literary way; but, in respect to his actual written texts, not literarily enough. Put this way, it becomes obvious why those who only read his words, and take them as hermeneutically self-evident, are left with no solid sense of this great architect's project on any level and are as much as unqualified to vote on the question of whether or not it was or is art at all. Let us try to consider, then, more of what is at stake for modern European art in its formative phase in 'Ornament and Crime' (1909) and 'Architecture' (1910) as differently and variously problematic as they are, in succession and as having implicit connections with other, less-known texts of the architect.[1]

The very title of the lecture and pamphlet

'Ornament and Crime' demands attention. Loos's use of the neuter Latinate *'das Ornament'*, not the masculine Germanic *'der Schmuck'*, already welcomes more general and categorical construal – even of the Romanized Greek orders as grammatical complexes passed on philologically through the Renaissance and then the classical academic system – as more than just a matter of cosmetic superfluities. Loos understood and respected the classical orders much more than the reactionaries who, still to this day, dumbly fetishize them: to him the understanding that they could no longer symbolize the essence of architecture as no longer a matter of stone upon stone, was no reason to consider them anathema. Also, in 1909 the title 'Ornament and Crime' would have carried a touch of the edginess of Karl Kraus, who had published a critique of sexual inequality titled *Sittlichkeit und Kriminalität* (Morality and Criminality) in 1902. The note of criminality carrying over from the Kraus title would have reinforced the known historical relevance to the Loosian problem of the early criminologist Lombroso, to whom we shall return. And on the heels of

Kraus had come another timely Viennese double-barrelled title with an ethical ring to it: Otto Weininger's sensational *Geschlecht und Charakter* (*Sex and Character*) of 1903.

Young Weininger had committed suicide soon after his book appeared, just as Loos's career was starting up; that might not seem pertinent but for something Allan Janik has pointed out: that according to *Sex and Character*, criminality as such is anti-social yet essentially *aesthetic*. In other words, though aesthetic conviction was not, for the moment, a selling point, a note of scepticism about aesthetic superficiality, specifically ornamental superfluity in architecture, quite possibly was. After all, criminality had even been toyed with in early modern aestheticism: in 1890 the dandyish American painter Whistler had promulgated in his *Gentle Art of Making Enemies* a list of revisionist aesthetic propositions, beginning with: 'That in Art, it is criminal to go beyond the means used in the exercise' (Whistler 76). In Weininger's terms, criminal behaviour is the result of an individual's being given monomaniacally over to pleasure as gained by any means necessary of possessive

consumption of his or her objects of desire (Janik, 'Paul Engelmann's Role' 49). But if that meant a bad mark for aestheticism as possible motivation for a bad life, let us not miss the Loosian point of this as, if anything, a propitious occasion for the definitive pronouncement of a very rhetorically inflected anti-aestheticism. This was particularly directed against the arty sensuousness of the Secession's entire decorative arts project; and if Loos seemed like Beau Brummell arguing against the threat of fashion when he stood up to say it, that might be all the more scandalously effective.

Taking these writings simply as nihilistic or Viennese-sarcastic may be a way of dismissing them that is seriously problematic in the case of such an ironist and wit as Loos. With 'Ornament and Crime' – when virtually all literate adults still assumed that ornament was precisely what set architecture as a fine art above mere building – Loos takes the lust for ornament as symptomatic of a lack of sublimatory cultivation. Chronic complaints about the presumed unfairness of imagery which entails that tribal peoples are not as advanced as Westerners, too often

miss or radically mistake the thrust and aim of Loos's literary figure, which, by means of analogy, exclusively concerns *modern city-dwellers*, however crude, merely unsophisticated, or positively decadent.

'Ornament and Crime' has become notorious for purported racism in taking a tribal people given to tattoo as an extreme of cultural inferiority, a problem which requires more literally critical attention than the dismissive moralism for which it has tended to be taken as an easy target. It is, however, not simply that the prevailing view distorts Loos's exposition by taking it out of context in a multi-imperial moment when such offences were regrettably commonplace in European and American establishment culture, though that is true enough: no, we are not looking for a loophole by which to save Loos's reputation by, as it were, 'innocence by association', not when the whole logical thrust of Loos's argument concerns *knowing better now*. Unfortunately, latter-day objection to the terms of the statements at issue, most often from a literary viewpoint, is so concerned with Loos's figures as not to be concerned to ascertain what Loos was

actually saying on behalf of architecture by employing them, as if only literary folk are allowed to put figures to work. So it may not necessarily be reactionary for one who cares about art and architecture to want to get past a problematic imagery, after a hundred years, in order to come to terms with this 'world-historic', if also notorious, text, the only work by our polemically inclined architect, with a high sense of irony, of which most people who have heard of him even know.

The essay stands in a certain German tradition of acerbic critique that includes Nietzsche as well as Loos's friend Karl Kraus. In 'The Use and Abuse of History for Life' (1873), for example, in the second volume of *Untimely Meditations* (or, *Thoughts Out of Season*), Nietzsche sounds quite Loosian in condemning the phoniness of culture as a mere cover, supposedly a 'decoration' of life but really a 'disfiguring' of it: 'for all adornment hides what is adorned' (Nietzsche, *Thoughts* 99). Then, in 'Schopenhauer as Educator' (1874), he speaks with Loosian sarcasm of how German culture can be expected to be Frenchified after overrunning France in the

Franco-Prussian War: '[W]e have no reason to mind the French despising us for our want of interest, elegance and politeness, and being reminded of the Indian who longs for a ring through his nose, and then proceeds to tattoo himself' (loc. cit. 162).

It is bad enough when readers of Loos fail to follow through with the sense of his references to cultural backwardness and atavism (neutral conditions in pre-industrial cultures, European and otherwise) as figures critically directed at the 'barbarisms' (metaphoric but fully culpable) all too rampant in modern, supposedly refined, societies. But it is either naïve or unfair to criticize Loos's evolutionary presuppositions in the matter – which owe nothing to the horrors of 'social Darwinism', and it is scandal-mongering to make it seem they do – without acknowledging the only available theoretical alternatives. The progressivist sense of cultural evolution appealed to by Loos, whereby differentials in cultural development are differences, parallel in the prevailing historical time, in the playing out of the same cultural scenario, rests on 'uniformitarianism' in the geology of Darwin's friend

Charles Lyell, by which the forces shaping the earth today are presumed to be the same as those which shaped it in the distant past. I like to think that, given his penchant for mirror-play in interiors, Loos would have been interested in a younger Hungarian anthropologist turned Freudian analyst, Géza Róheim, a defender of cultural evolutionism who also studied folkloric 'mirror magic' (*Spiegelzauber*, 1919; Robinson 84–89). However, the only alternatives to such 'cultural evolution' or 'parallel development' were (a) diffusionism, whereby every advance in culture must be a hand-me-down from another culture, or (b) functionalism, in which the historical dimension is ignored and each culture's hardware and myths belong to a game so closed unto itself as not even to be comparable to another. So unless one would have preferred either (a) or (b) instead, one should by rights make some peace with Loos's *highly figured* appeal to some sense of cultural evolution.

Thus when the German predecessor in modern social criticism of architecture, Hermann Muthesius, had written only a few years before 'Ornament and Crime', in his *Style-Architecture*

(2nd edn, 1903), as noted, of 'a barbarism, such as our culture had not seen before, penetrat[ing] the substratum of the trades with little notice' (Muthesius 59) without even incidentally offending contemporary tribal peoples, he was deliberately offending his own, once tribal German people. Loos even seems insistent and repetitious on this theme, which does not entail less developed peoples being less human, but does insist that some people *among us* ought to know better than to do the sorts of things that people less constrained by civilization do, and hence are distinctly *culpable* where tribal peoples are definitely not.

But the matter of tattooing in particular, especially the tattoo art of the Maori people of New Zealand, coded in a way by Loos as 'Papuans', has special significance, though for present purposes there is no need to observe ethnological distinctions between references to Maori (Polynesians of New Zealand) and Papuan (Melanesians of New Guinea) tattoo or other ornamentation. It is enough to note that the serious ethnographic reports and collected artworks of the Maori proved to have serious

artistic interest to the great Viennese critical art historian Aloïs Riegl (Masheck, 'Vital Skin'); thus it seems likely that Loos's talk of Papuans was laterally caricatural, to some extent sending up the Western infatuation in the one case with the name of another comparable group, though Maori ornament is as a rule more curvilinear. Also, as may become evident, the Maori people were better known to Western culture, so that if anything, Loos may have turned to the less theoretically rehearsed category. Otherwise, the still looser, and more regrettable, usage 'Red Indian', now found in some translations of Loos – most conspicuously in a quotation at the beginning of E. H. Gombrich's *The Sense of Order: A Study in the Psychology of Decorative Art* (1979) – cannot be blamed on him. However objectionable, it is a standard Britishism for distinguishing Native Americans or American Indians from what the British would more usually mean by unqualified 'Indians', i.e. the people of India. Wherever it occurs, Loos himself used *der indianer*, the special German word for American Indians, as against *der indier* for Indian Indians (the lower case 'I' is no insult

because Loos preferred to drop the usual German capitalization of nouns).

There is some consensus that Loos's attenuated tattooing trope owes something to the positivist and determinist criminology of Cesare Lombroso, which was widely read by the turn of the century: in America, an article by Lombroso titled 'Savage Origin of Tattoos' appeared in *Popular Science Monthly* for April 1896. Lombroso's classic *Criminal Man* (1876), expanded four times (5th edn, 1896–97), already contained a long chapter on that most remarkable of 'criminal stigmata' (meaning marks deviating from a standard ideal of beauty), tattooing, which Lombroso finds confined to the lower classes and, especially, criminals. He thought that the word for tattooing comes from 'an Oceanic language' (one doubts that this can mean the Maori *ta moko* as resembling the Italian *tatuaggio*), and observes that the only men who had tattoos on their backs or pubic areas had either been in prison or 'to Oceania' (Lombroso 58). Tellingly, with a view to Loos's text: 'Among Europeans, the most important reason' for being tattooed is 'atavism and that other

form of atavism called traditionalism, both of which characterize primitive men and men living in a state of nature'. Such atavism is not simply primitivism by another name, even if primitivism appeals to it. 'It is only natural that a custom widespread among savages and prehistoric peoples would reappear among certain lower-class groups', including sailors and prostitutes, the former 'display[ing] the same temperament as savages with their violent passions, blunted sensitivity, puerile vanity, and extreme laziness. Sailors even adopt the habits, superstitions, and songs of primitive peoples' (61–62). Lombroso saw tattooing as closely tied to criminality in contradistinction with insanity; and Allan Janik believes that 'Ornament and Crime' 'depends entirely upon Lombroso's premises' (Janik, 'Weininger' 29). That can be factually true as a point of departure without denying that Loos's shamelessly independent wit would have found scope for play with a Lombroso phrase like 'that . . . form of atavism called traditionalism'[2].

A case from the second edition (1878) is telling for what it says about Lombroso's sense of art. A murderer named Cavaglià decorated his

prison water jug by scratching into the glaze simple drawings of his acts of murder and planned suicide; these are deemed sufficiently self-evidently inept to justify the judgement that 'he told the story in a mixture of words and pictures in a way that evoked the customs of savage peoples, whose language is too poor to clearly express complicated ideas' (151). In the fourth edition (1889) Lombroso has, at his fingertips for just such situations, a new technique, 'pictography', based on the notion that '[c]riminals tend to express their thoughts through drawings, even when they could express them in words'. But this is because of something presumably atavistic as such about 'a picture' versus 'writing', so that, again, '[a]part from atavism, it is impossible to find another explanation for the custom of tattooing' (239).

At the same moment the Norwegian writer Knut Hamsun (later a fascist), reporting in a now sometimes disturbingly racist way on his rather negative first-hand experiences of *The Cultural Life of Modern America* (1889) – an account that would have piqued Loos's curiosity if only for its criticism of American affectations

of petit-bourgeois British ways – mentions New Guinea natives in connection with cultural atavism. Human breeding, in the sense of cultivation, is likened to animal evolutionary stages: 'When the fish became a bird, it learned better manners.' After an observation on the curious ways New Guinea and Malay tribesmen greet one another, Americans' adoption of a suburban English 'How do you do?' is attacked as belonging to the 'dog stage' of culture: this 'is *their* greeting – an expression of their temperament and level of development' (Hamsun 136–37). Whether or not Loos read Hamsun, the provocative report on America by this eventually famous novelist had a place in the career of the literary topos of the backward New Guinean or Maori.

In the interest of overcoming the persistent nineteenth-century naturalist notion that 'merely' ornamental forms do not qualify as art, let us note that by 1870, in his *The Origin of Civilisation and the Primitive Condition of Man*, the tattoos of the 'Polynesians' favourably reminded Sir John Lubbock, the very framer of the Palaeolithic/Neolithic distinction, of Bronze Age Greek spirals (Lubbock 26). In 1885, well before Riegl's

discussion of the Maori's spiral ornament as an all the more decisively formal matter in the absence of the metal tools which would have made it more readily determined, the anthropologist Otto Finsch, commenting on Papuan tattooing as *clothing* the body (*'Bekleidung'* finds an English cognate in 'cladding'), called attention to a particular kind of tattooed men's belt. Because such work was so difficult to execute without iron tools, 'it must be unconditionally characterized as artwork' (Finsch 14). On the hurried, 'downtown' terms of 'Ornament and Crime' it might seem absurd to think that ornament's being extra-difficult to execute should make it more art-worthy; but in fact, this is exactly how Maori ornament would serve the more 'idealist' argument of Riegl in *Stilfragen* (*Problems of Style*; 1893), against the 'materialist' view of Gottfried Semper: that this shows the Maori carvers' spirals as something they *really wanted to make*, not something that more or less *had to come out that way*, given the materials, tools, 'techniques'.

Problems of Style, subtitled *Foundations for a History of Ornament*, has a diffusionist theoretical

thrust – diffusionism, again, being the theory that similar art forms do not arise independently but through lines of transmission. Yet Riegl's speculations on Maori ornament were ultimately in the interest of modern artists and modern art. The same cannot be said of a once classic diffusionist attempt, published shortly after Loos's death, to situate Maori ornament globally by locating its source in sophisticated Zhou dynasty Chinese ornament, calling it 'a barbarized (*barbarisé*) art ... that could only have been born in a high civilization' (Heine-Geldern 202). Comparing Maori with Scandinavian interlace ornament, the same scholar – though he has to admit that thought of a connecting population is far-fetched – points to Josef Strzygowski's notion of 'real ties between ancient art of Northern Europe and the art of New Zealand', while he himself suggests that autochthonous Neolithic spiral ornament of Bohemia and Moravia did reach the Far East (204). It might be entertaining to imagine what Adolf Loos could have added to 'Ornament and Crime' about Bukovina as ultimate formal source for the ornamentation of the great Shang

or Zhou dynasty bronzes! Here, supposedly, was the connection between the Maori and the Scandinavians: the Zhou dynasty, before it 'strongly influenced the art of New Zealand', had itself inherited 'Danubian' and 'ultimately Mycenaean' forms; and this may well make for an indirect connection between the Scytho-Sarmatian forms of the steppes too, and New Zealand (205). Something of a Maori sort – Loos's 'Papuans' – was stirring.

Loos was an Anglophile and proud of it, aspiring in a way to a visual equivalent of the stiff upper lip as an epitome of developmental refinement connoting an unaffected, confident civility, social but private, with a 'noble simplicity' of public restraint. This character, which also pervades his concern with tailoring, also evokes, once again, the often impassively classico-plain façades of Neopalladian country houses. The diffusion of the British Neopalladian style had extended in the later eighteenth century into Central Europe (examples include Schloss Williamshöhe, near Kassel, and Schloss Belvedere at Warsaw), although the forced spatial symmetry of the interior layouts of Neopalladian

buildings, even medium-sized private houses, is something one cannot imagine Loos bearing to impose (worse than the rigorous surface symmetry of the Papuan or Maori's facial tattoo?). What might be considered proto-Loosian in the Neopalladian mode, and in turn a root of Neoclassicism, was its essentially rationalist critique of Baroque rhetoric. Thus there is something of the spirit of Loos in the chapter 'On Building Without Any Orders' in Marc-Antoine Laugier's *Essai sur l'Architecture* (1753), where the great proto-functionalist practically preaches, telling architects how not everything has to be grandly important, and how positively interesting it can be to compose a building with no classical 'order' of columns at all.

And as I have noted before, in his *Prolegomena to Any Future Metaphysics That Will Be Able to Come Forth as Science* (1783), Immanuel Kant speaks of a possible 'adornment ... through heightened clarity'. Indeed, Loos finds something of an ally in the Kant who produced a distinctly cleansing 'critical' philosophy. In remarks appended to his 1783 *Prolegomena*, which is something of a rehearsal for the *Critique of Pure*

Reason, Kant acknowledges his qualified idealism as having been provoked by the same George Berkeley even as he critiques Berkeley's 'dogmatic', and in proceeding to speak against ornamentation he employs two expressions that would surely have appealed to Loos, one as it were abstract and 'sentimental', the other, more vernacular yet 'anti-naïve'. The first concerns effecting 'adornment by greater clearness (*den Ausputz durch ... vergrösserte Deutlichkeit*)', while the second recasts much the same basic conception in a homey figure worthy of the farmhouse: 'though the old false feathers have been pulled out, it need by no means appear poor and reduced to an insignificant figure but may be in other respects richly and respectably adorned' (Ak. 382; Kant *Prolegomena* 122; *Werke* 4: 138).

Some of Loos's smaller, but by no means insignificant built projects, early on, show him subsuming appropriate formal influences even where, a century ago, there would not have been enough to describe as ornament. Similarly, ignoring an element of eclecticism, something like a default of English Regency style also has

Anglophile relevance to Loos's work. For instance, in two early boutique-sized Viennese shop fronts – the Sigmund Steiner Plume and Feather Shop (1907; demolished) and the Kniže haberdashery in the Graben (1909; 1913) – a quarter-rounding of the shop-windows at the doorway, or at the Kniže store, of plinth and showcases left and right, pays formal respects to the boutique shop-fronts of Samuel Ware's elegant Burlington Arcade of 1819 – which may even have been under discussion at the time because the Piccadilly entrance was soon to be remodelled, in 1911 (by Beresford Pite).

Loos's Anglophilia was not peculiar in contemporary Germanic artistic culture. Muthesius' major, handsomely illustrated study *The English House* (1904–5), researched while its author was German cultural attaché in London, conveyed an impressive sense of the English 'free style' and newly 'open' planning. One of the more overlooked candidates for influence, or at least corroboration, of what would become Loos's way of thinking might be the Welsh-born *décadent* poet Arthur Symons, who was sufficiently popular in Loos's world for several of his fictional works to be

translated into German and even Czech early in the new century. Symons addressed the eminently Loosian theme of the plain being all the harder to come by than the meretriciously ornamented. In an essay of 1903 on 'The Decay of Craftsmanship in England', after criticizing the cult of the 'detachable picture' together with stuck-on ornament, Symons says:

[W]e have become specialists; the craftsman is no longer an artist, and the artist can no longer be a craftsman. What we see in the Arts and Crafts, in these ambitious attempts, is only another symptom of what we see in all the shops in London. The most difficult thing to get in London is a piece of plain carpet, without any pattern on it whatever, and when you have found it you will generally have to get it dyed to the colour you want. A piece of plain wallpaper to match it will be the next most difficult thing to get; and for both these things you will have to pay much more than you would pay for a carpet or a wallpaper covered with hideous patterns. Surely the mere printing, not to say inventing, of these patterns must cost money; why, then,

cannot a cheaper and a less objectionable thing be offered to you without them? For this reason, say the shopkeepers, only one person out of a thousand will buy it. That the pattern is a bad pattern, no one seems to mind; there must be some scrawl for the money. (Symons 183–4)

I read this passage into the record because, as will become evident, it so closely resembles critical complaints soon to be lodged in this, Loos's most famous text, 'Ornament and Crime'.

That text is a great reformist contribution to early modernism as worthily high art. It will be best to deal straightaway with the problem of its now problematic culture-evolutionary aspect, if, that is, we can for once, in this situation, keep our eyes on the ball of what Loos, despite any now objectionable terms, was actually trying to say. But if the view on which Loos leans for his sense of the cultural-evolutionary aspect of 'Ornament and Crime' was biological seems cause for concern now, at least it is one which has retained some cultural respect as a figure of thought: the notion, framed by Ernst Haeckel, that the embryological 'ontogeny' of the single

human being developmentally 'recapitulates' the anatomical form of 'the phylogeny', that is, the overall developmental species pattern of the animal kingdom at large. In its time, the theory countered the pessimistic press of destiny in the more social Darwinist view. More importantly for the text at hand, it was the basis of a cultural analogy that in Loos's hands was not evidently any more tainted by racism than were most other liberal-minded middle-class Europeans in 1909, or anyone who went on to welcome the 1919 revolutionary spirit in Central Europe and gave serious attention to social housing, etc. For the cruder early phases of human culture consisted by definition of the best there was at the time – just as Marx can speak well of feudalism over and against slavery; and indeed, Loos points up at the start of his text something of which most Americans have no inkling when he sets between the innocent (though not exactly noble-savage) Papuan (= age two) and Socrates (= age six), in his developmental scale of culture, the pre-feudal European 'tribesman' (= age four; OC 167) so conveniently forgotten in the modern Euro-American's sanitized sense of his or her own origins. In any

case, the thrust of Loos's figure was not to criticize anybody else's lack of sophistication but only the contemporary 'stragglers' as he calls them more than once, of his own modern culture, who, he always insisted, really ought to know better.[3]

Given his critical outlook, a different sort of embryological speculation, anciently Indo-European, would have appealed to him in respect to architectural cladding as a building's embryologically final epidermis: the original Sanskrit conception of ornament as final, outermost layer of something properly crafted as it comes into its own. The great orientalist Coomaraswamy (1877–1947) explains that by linguistic devolution the Sanskrit word meaning 'made adequate' came more simplistically to mean merely 'embellished'; the debased usage 'I adorn him' had once meant something more profound that would have appealed to Loos: 'I fit him out' – as an outfitter (Coomaraswamy 378). Of special interest to our modernist architect who loved well-crafted saddlery would have been a discussion of words pertaining to harness, as where, in the Rig Veda, what matters is the *aptness*, not superficial 'beauty', of the gear. Loos

would agree with Coomaraswamy that mere aestheticism is childish, though not about how that matters: unless we get beyond it, we cannot comprehend the fundamental meaning of such bodily adornments as 'tattooing' (380).

'Ornament and Crime', however, does propose a progression – like Haeckel's formula of the ontogeny recapitulating the phylogeny, that is, that the human embryo recapitulates 'all the evolutionary stages of the animal kingdom'. '[W]hen a human being is born,' Loos says, 'his sense impressions are like a newborn dog's. In childhood he goes through all the stages in the development of humanity' (OC 167). Thus develops the present-day child:

At two he sees with the eyes of a Papuan, at four with those of a Germanic tribesman, at six of Socrates, at eight of Voltaire. At eight he becomes aware of violet, the colour discovered by the eighteenth century; before that, violets were blue and the purple snail was red. Even today physicists can point to colours in the solar spectrum which have been given a name, but which it will be left to future generations to discern (ibid.).

This last point is important because it implies that, like the Papuans, we moderns are not incompletely human today just because cultural development is likely to continue, culture being a process of refinement that is never over. Loos cannot be arguing that Voltaire was better than and/or superior to Socrates, which would follow analogically if the Teutonic tribesman were better than the Papuan. Then, too, there is the idealizing respect for the Papuan that a perhaps dandyish Voltaire must have for a Socrates.

But in the second paragraph the now century-old but notorious account of tattoo begins; and the present-day critical reader would do well to remember that the Maori as well as the Papuans, were cannibals, notwithstanding their undeniably beautiful ornament, including tattoo. Some confusion with regard to 'Ornament and Crime' derives from the fact that Loos is already more culturally relative than is expected: the Papuan's cannibalism cannot be fully culpable because he literally knows no better: 'But if a modern person kills someone and devours him, he is a criminal or a degenerate' (ibid.). Similarly, then: 'The Papuan covers his skin with tattoos, his boat, his oars,

in short everything he can lay his hands on.' But: 'He is not a criminal.' (One might have expected Loos to complete the parallelism with 'nor a degenerate', but he may want to leave room for a touch of *décadence*.) 'The modern person who tattoos himself is either a criminal or a degenerate' – a thought that unfurls into a wittily hyperbolic Loosian cadenza: 'There are prisons in which eighty per cent of the inmates have tattoos. People with tattoos not in prison are either latent criminals or degenerate aristocrats' (*OC* 167). 'If a tattooed person dies at liberty, it is only that he died a few years before he committed a murder' (*AAL* 100).

Loos obviously knows he is being outrageous; and in estimating what he is intellectually up to we should not overlook his Viennese high sarcasm. As Peter Vergo notes with uncommon boldness, 'critics have failed to notice' that in this prime text Loos is 'far from being entirely serious', and statements like the one of dying fortuitously before committing an inevitable murder, are 'surely humorous' (Vergo 172). An amusing example from one of his early exhibition reviews, on 'Glass and China' (1898), has our subject

talking about a popular engraver of drinking glasses at this exhibit of wares engraving people's names 'while-they-wait': 'Particularly delightful is a goblet decorated with good-luck charms, which I am sure has a future ... What I have in mind is the delightful arrangement of the charms, which recalls the principle of decoration under Emperor Francis I' (*OC* 72). While the irony in 'Ornament and Crime' is subtler than that, it is strange that our literary friends, of all people, often seem to suppose that when this friend of Kraus, criticizing contemporary European culture, made such a statement as that someone tattooed dying at liberty would soon have become a murderer, he can possibly have been speaking with a straight face. Yet beyond the scandalous hyperbole there was important thinking here – a hundred years ago now, amazingly:

The urge to ornament one's face, and everything within one's reach is the origin of fine art. It is the babble of painting. All art is erotic. The first ornament that came into being, the cross, had an erotic origin. The first work of art, the first artistic action of the first artist

daubing on the wall, was in order to rid himself of his natural excesses. A horizontal line: the reclining woman. A vertical line: the man who penetrates her. The man who created it felt the same urge as Beethoven, he experienced the same joy that Beethoven felt when he created the Ninth Symphony. (*AAL* 100)[4]

Loos's concern is not with an absolute primitive state of nature but with a relative primitivism under supposedly advanced developmental conditions. His observations here on the barbarous behaviour of his more uncouth contemporaries stir up matters not only of anthropology but also of historical and political philosophy, including Giambattista Vico's pre-Nietzschean sense of cultural progress as repeatedly broken by regression to a more primitive state, with recovery to a somewhat higher plane; and of how in the final 'Age of Man' a barbarism comparable to the 'second barbarism' of the early Middle Ages returns with social breakdown and 'barbarism of the soul' (Vico, conclusion to *The New Science*, 1725). Closer to home, the Industrial Revolution had brought the social barbarism of

alienation and cultural deprivation of a lumpen-proletariat which Loos obviously has in mind without putting it quite so. Even a notorious comment on those who inscribe and bedeck with drawings public lavatory walls comes closer, in tenor, than we would expect to Engels in *The Condition of the Working Class in England in 1844* (1845) on the slums of Manchester as habitable only by 'a physically degenerate race, robbed of all humanity, degraded, reduced morally and physically to bestiality' (Engels 63).

Loos finally makes a decisive and sweeping point when he insists, '*We* have the art that has superseded ornament' (*OC* 174; emphasis in source). 'The art, which has taken the place of ornament,' the same notion of supersession and even sublimation will even extend (once there is such a thing) to abstract painting as in part adumbrated by ornamental stylization in the crafts; and this is also a good condensation of the whole case that 'Ornament and Crime' was never about how the tribal artisan doesn't know any better, and not even about how the lowly present-day cobbler doesn't know any better either, disappointed as he is when you offer to

pay him more if he will just make your shoes without the absurd 'wing-tip' pattern of dots – a markedly sharp criticism on Loos's part, which has a fourth-century Eastern precedent: St John Chrysostom preaching in Constantinople: 'Even the shoemaker's ... [art] stands in need of restraint, for they have lent their art to luxury, corrupting its necessity and artfully debasing art' (Homily 49 on Matthew, qu. Coomaraswamy 381). No; it is really about how *we* are remiss: 'What is natural in the Papuan or the child is a sign of degeneracy in a modern adult. I made the following discovery, which I passed on to the world: *the evolution of culture is synonymous with the removal of ornament from objects of everyday use*' (*OC* 167; emphasis in source). However questionable – '*they* don't know any better' – as a set-up, the challenging punch line, as it were, of Adolf Loos's message was and undeniably remains '*we ought to* know better'.

Yes, Loos has to report that his attempt to announce the good news that ornamentation as such is now over with, and that the production of ornaments might finally cease, has not pleased but disheartened people: 'What? We alone, the

people of the nineteenth century, were not cap-
able of doing something every ... tribesman
could do, something every age and nation
before us had done!?' (*OC* 167). From this sen-
tence I have dropped a casual and unnecessary
mention of race, because, usage in such things
now being more sensitive (which Loos would
take as improvement), the word in question is by
now, 100 years later, a distraction from the real
object of Loos's analogical concern with the
unsophisticated provincials of the contempo-
rary Austrian empire as all the worse for having
less excuse than surviving non-European tri-
bal cultures. Of the jubilee parade of Emperor
Franz Joseph in 1898, with its endless files of
ethnically costumed imperial subjects from every
corner of the empire, he says with typical outra-
geousness, '[W]e shuddered to learn that here in
Austria we still have tribes from the fourth
century. Happy the land that does not have
many cultural stragglers and laggards. Happy
America!' (170). It was with these 'stragglers',
here the peasants within the outer limits of the
Austrian empire, that Loos was primarily con-
cerned with all his imagery of the primitive in

'Ornament and Crime'. Otherwise, 'otherness' as such was hardly a distasteful condition for this cultural loose cannon who titled the short-lived journal for which he wrote the copy himself *Das Andere* – 'The Other'. As for the presumption of a modern European's necessarily patronizing pre-modern culture as backward vis-à-vis modern urbanity, Loos spoke at a moment of cresting conviction in Germanic Expressionism, which inherited a German Romantic appreciation of primitivity. As early as 1799, the *Heartful Outpourings of an Art-Loving Monk*, of Wilhelm Wackenroder, had called tribal music as good in the eyes, or ears, of God as the chants of the Church (cf. Masheck, 'Raw Art'). That was more to the modern point than the Baltic German historical writer Carl Gustav Jochmann's essay 'The Regression of Poetry' (1828), taking primitives' scarification, probably more than tattoo as such, as plainly evil (no doubt in light of Leviticus), which Walter Benjamin seems to have rediscovered in awareness of Adolf Loos.[5]

Let us be clear: there was no onus whatever in sophisticated circles on being primitive as such – the condition was even romanticized – only on

behaving inexcusably like a primitive in the middle of Vienna.

Moments after the turn of the century Aloïs Riegl, who had already written a short book on folk art, and then *Problems of Style*, which actually engages with Maori tattoo, produced the first volume of a momentous book aesthetically rehabilitating the barbarian metalwork of precisely that 'Migrations' period to which Loos referred, published by the imperial and royal press in 1901, as if in celebration of the dual monarchy itself, under the title *Die spätrömische Kunst-Industrie; nach den Funden in Österreich-Ungarn* (Late Roman Art Industry; Based on the Finds in Austria-Hungary; 1901). If concern with such 'industrial art' was, by and large, more akin to the Secessionist sense of 'decorative art' from which Loos distanced himself, other studies of the turn of the century were also important. Consider an illustration of Maori tattoo from an influential German book whose enthusiasm for tribal art was nationalistically concerned with the new German overseas empire; but it also had the perhaps more interestingly nationalistic motivation, according to Goldwater, that hearty tribal peoples

were to its author, Leo Frobenius, surprisingly German or at least appealingly unlike the French. The title, with all its implications, if not the actual book, would surely have been known to Loos: *The Childhood of Man* (1901; English translation, 1909), though the original title is more apologetic: *Aus den Flegeljahren der Menschenheit*: 'Out of Humanity's Awkward Age'.

A parallel can even be suggested between a certain Papuan or Maori tattoo type from timelessly 'outside' the European sphere and Riegl's tendril motif as amazingly genealogically continuous down through the ages in Western art. Thus can a type of wood-carved stamp illustrated by Frobenius, which one might suppose was for textile printing but which is in fact a tattoo pattern from Borneo, compare with a mechanically printed wallpaper pattern, perpetuating the tendril motif in Loos's Vienna, in Freud's apartment at Berggasse 19, in the IX District of Vienna (between 1891/92 and 1938). Also, the otherwise culturally distinct Borneo Dayaks, Melanesian Papuans of New Guinea and Polynesian Maori of New Zealand had the practice of tattoo in common; and such stamps

for tattooing occur in the latter cultures as well – more remotely from Southeast Asia, with which the diffusionist would associate the Borneo one in order ultimately to connect up, across Asia, with the Western lineage. Freud's wallpaper will simply stand for all the ubiquitous leafy scrollwork, based on the tendril motif whose formal genealogy Riegl had worked out in Freud's generation, a little ahead of Loos. It is also a good generic example of what Otto Wagner, a bit older still, basically conceived as ornamentally claiming a wall, like a clinging vine, as a faced surface, as, so beautifully, on the façade of his great Viennese apartment block, the Majolikahaus, of 1898. Loos himself used wide, rich vegetal friezes, related to tendril ornament (with interjected tailor's shears), in the Ebenstein Tailoring Salon, Vienna I, of 1897.

Janet Stewart has explored Loos's 'Papuan' theme, associating it, reasonably enough, with the living exhibition, in a Viennese zoo in 1897, of an ' "African village" peopled by Ashanti men and women', as instigating a spectacle of exotic tribal 'otherness' in the background of Loos's 1898 Jubilee Exhibition essays – after

perspicaciously suggesting that the more remote 'otherness' of Oceanic tribal villagers may have symbolically mitigated Loos's personal situation: for though culturally 'German' (by language) and Catholic, he was a Moravian-born cosmopolite with many Jewish friends at a time when Czechs and Jews were the largest categories of 'others' in Vienna.

But attention needs to be paid to how the essentially ornamental-abstract Maori art became sufficiently familiar, particularly in turn-of-the-century Vienna, to be available for Loos to put it to analogous work in his famous or infamous text. Two factors were at work here: a serious Western artistic interest in native Maori art was already being taken for a long time; and the less happy fact that, as reduced to a preserve within a functionally 'Western' country, New Zealand, Maori culture was already quite 'on the map'. In 1907, before 'Ornament and Crime' was drafted, something of an intersection occurred between Maori and upper-class British culture that would have amused Loos: in honour of New Zealand's passing from British colony to dominion status, Royal Doulton produced a china pattern based

on the highly curvilinear patterns of Maori house decorations. By 1910 the Maori were sufficiently part of the 'world' of Western imperial culture, however subordinated, to be visited by John Philip Sousa's band on their world tour of that year. (I have, from my grandfather, a souvenir photograph printed as a postcard to be sent home by members of the band, who appear standing with some Maori people before a new-looking but traditionally ornamented Maori dwelling-house).

Maori art-historiography is a happier subject than imperial conquest. Maori ornament tattoo and other curvilinear ornament has a long history of aesthetic citation in the West after Captain Cook's and Joseph Banks' collections and reports, including not only the former in Kant's *Critique of Judgment* (1790) but also, as I have pointed out, the latter in the British neoclassical sculptor John Flaxman's lecture on 'Style' (Masheck, 'Vital Skin,' 158–60; though in my previous treatment of this problem I was too sceptical of Loos's sweeping negativity, which was braced against prevailing excess). Possibly the earliest disseminations of visual evidence of

Maori ornament in France were two articles in the then new *Magazin pittoresque* in 1833 (Donne, 5–6), and prints of the great Romantic etcher Charles Meryon.

Aware of Flaxman, the American sculptor Horatio Greenough wrote in 'American Architecture' (1843):

When the savage of the South Sea islands shapes his war club, his first thought is of its use. His first efforts pare the long shaft, and mold the convenient handle; then the heavier end takes gradually the edge that cuts, while it retains the weight that stuns. His idler hour divides its surface by lines and curves, or embosses it with figures that have pleased his eye or are linked with his superstition. We admire its effective shape, its Etruscan-like quaintness, its graceful form and subtle outline, yet we ignore the lesson it might teach.

This sculptor shows a lively response to such 'primitive' ornamental art even before the New York novelist Herman Melville returned from the Pacific and stimulated popular interest in

Oceanic culture with *Typee: A Peep at Polynesian Life* (1846) and *Omoo: A Narrative of Adventures in the South Seas* (1847). Greenough follows through with the Loosian-Corbusian proto-functional statement of that lesson:

> If we compare the form of a newly invented machine with the perfected type of the same instrument, we observe, as we trace it through the phases of improvement, how weight is shaken off where strength is less needed, how functions are made to approach without impeding each other, how straight becomes curved, and the curve is straightened, till the straggling and cumbersome machine becomes the compact, effective, and beautiful engine. (Greenough 59)

Maori tattoo and ornament were then taken up by Owen Jones, but then too by John Lubbock and, notably, by Riegl in Vienna, of whom Loos was aware. The first book to distinguish the Old and New Stone Ages – Lubbock's *Pre-Historic Times; As Illustrated by Ancient Remains and the Manners and Customs of Modern Savages*

$(1865)^6$ – two illustrations of facial tattoo from his *Origin of Civilisation and the Primitive Condition of Man* were re-published by Riegl along with his own 1890 illustrations of Maori weaving and carving in his great anti-Semperian work of 1893, *Problems of Style*. There followed in the same line not only the expressionist theoretician and Riegl enthusiast Wilhelm Worringer, but also, in Vienna, Adolf Loos.[7]

Only a few years before Loos began to write criticism, another classic work on prehistoric art appeared, treating both Maori and Papuan ornament, which would have facilitated his effective substitution for a more longstanding topos of the Maori by his Papuans: *The Beginnings of Art* (1894) by Ernst Grosse. Papuan canoe-prow ornaments are mentioned along with Maori ornamental and figurative art, with Grosse suspending aesthetic judgement on Maori figurative work, interestingly enough, because he cannot tell whether respect for convention has disadvantageously affected figures which seem to him less than adequately naturalistic. Grosse is generally concerned with tattoo, not particularly

with Maori or Papuan practices. Of Loosian interest is his sense that tools very often go unornamented even among peoples who do tattoo their bodies, except that one may often 'recognize embellishment not in ornamental decoration only, but in the smooth and even finish of an implement' (115). That is from Grosse's chapter on 'Ornamentation' in which reverberations of Riegl's contention with Semper can be discerned, and in which Loos would have noticed the sense of progressing developmentally 'higher':

Ornamentation has in [the] lowest stage of development only a secondary artistic character; pleasing forms attach themselves to the practical, significant features only as the tendrils of a young climbing plant to the branches of a tree. But later on the vine develops faster and more richly than the tree, and finally the form of the tree almost disappears under the dense green foliage and bright blossoms of the vine . . . There is . . . a great difference between the ornamentation of the primitive and that of the higher

peoples in nature, and consequently in influence. The ... social influences of the higher forms of ornamentation ... are certainly not insignificant, whenever, at least, the shameful prostitution of ornamental art to the interests of our modern manufacturing enterprise has not destroyed its charm and force. (Grosse 162)

Grosse still assumes like a good Victorian burgher, if unlike Loos, that ornament fluoresces with cultural development, though he has room for the insight that we can respond aesthetically to 'embellishment' not only in ornamentation but in, in a sense of the opposite, the smooth, even feel of a presumably plain tool.

Loos had introduced the theme before 'Ornament and Crime', only four years after Grosse's *Beginnings of Art*:

The great development of culture in this century has left ornamentation far behind. Here I must repeat myself: The lower the cultural level, the greater degree of ornamentation. Ornament is something that must be overcome. The Papuans and criminals decorate

their skin. The Red Indian covers his canoe over and over with decoration. But the bicycle and the steam engine are free of decoration. As it progresses, culture frees one object after another from ornamentation. (*OC* 109)

That is from 'Ladies' Fashion', 1898, revised in 1902. The bicycle motif occurs even more tellingly in other of Loos's 1898 reviews. In 'Glass and China', even the rhetorical concession that the Greek vases are 'as beautiful' as a machine or a bicycle attaches to a praise of modern engineering that includes the salute to engineers (and the English) as 'our ancient Greeks'. In 'A Review of Applied Arts – I', after noting the modern bentwood Thonet chair as 'the fruit of the same spirit' as an elegant Greek chair, Loos praises the bicycle again, this time as worthy of comparison with ancient Greek bronze tripods: 'I do not mean the votive offerings, but the ones that were put to practical use – are they not exactly like our own constructions of iron?' (*OC* 134–35).[8]

In 1907 and 1908, leading up to the lecture, the same parity of 1898 persists. In Loos's

promotional tour brochure 'Guided Tours of Apartments' (1907): *'The inability of our culture to create new ornament is a sign of greatness.* The evolution of humanity goes hand in hand with the disappearance of ornamentation from objects of everyday use. Whatever our applied artists, prompted by the survival instinct, might say, for people of culture a face without a tattoo is more beautiful than one with a tattoo, even if designed by Kolo Moser himself. And people of culture also want not only their skin but also their bookbindings and bedside tables protected from the Indian ornamental frenzy of these self-appointed cultural barbarians' (*OA* 54). Again, in 'Surplus to Requirements (The German Werkbund)' (1908):

It is a fact that the cultured products of our time have nothing to do with art ... The Papuans cover their household goods with decoration ... Albrecht Dürer was allowed to produce shoe patterns. But to modern man, glad he is living today and not in the sixteenth century, such a misuse of artistic talent is barbarism.

This separation was a good thing for our intellectual and cultural life. The *Critique of Pure Reason* could not be written by a man with five ostrich feathers in his cap, the *Ninth* did not come from a man with a plate-sized wheel around his neck, and the room where Goethe died is more magnificent than Hans Sachs' cobbler's workshop, even if every object in the latter were designed by Dürer. (*OC* 155)

Obviously Loos does not mean that Dürer is even relatively inferior to any modern artist, so it cannot be entailed that a Papuan's ornamental design is inferior to Dürer's shoe design: no, but even Dürer's shoes are on the wrong track for what is wanted in modern culture.

While the notoriety of 'Ornament and Crime', along with the scandal among the burghers of the Looshaus, undoubtedly helped to certify the avant-gardist's controversial standing, already in 1911 Loos had to explain that people misunderstood his position if they thought he was categorically against any and all ornament. 'Thirteen years ago,' he wrote, i.e. in 1898, in an essay

on 'Otto Wagner' (whose disciples he found worse ornamentalists than their master),

> I sent out a warning, expressing the opinion that we are no longer capable of inventing new ornamentation. (My enemies take this to mean that I am opposed to all ornamentation, while all I oppose is any kind of imitation in materials.) Anyone who wants to decorate something should therefore use old ornamentation. I do not consider the invention of new ornamentation as a sign of strength but – in cultivated people – a sign of degeneration. The Papuans can go on inventing new ornaments until they finally reach the stage when they are beyond ornament. (*OA* 90)

In the 1920s, writing on 'Ornament and Education' for a Czech review, Loos repeats himself on the same lines, in 1924 actually referring back to the original 'Ornament and Crime' lecture – and, if seemingly by a slip, advancing the age of the figurative Papuan: 'Every child is a genius. Not only its parents and aunts know that, we all know it. But the genius of a Papuan,

that is of a six-year-old child, is of no use to humanity' (*OC* 184).

> Form and ornament are products of the sub-conscious collaboration of all members of a particular culture. Art is the complete opposite. Art is the product of the genius going his own way. His commission comes from God.[9]
>
> To waste art on objects of practical use demonstrates a lack of culture. Ornamentation means added labor. The sadism of the eighteenth century, burdening one's fellows with superfluous work, is alien to modern man. Even more alien is the ornamentation of primitive peoples [another unlikely polemical equation, between the supposedly most civilized and the supposedly least], which is entirely religious or – symbolically – erotic in significance, and which, thanks to its primitive nature, comes close to art . . . (185–86)
>
> Twenty-six years ago I maintained that the use of ornament on objects of practical use would disappear with the development of mankind . . . By that I did not mean what some purists have carried *ad absurdum*, namely that

317

ornament should be systematically and consistently eliminated. What I did mean was that where it had disappeared as a necessary consequence of human development, it could not be restored, just as people will never return to tattooing their faces. (187)

At the end of the decade the theme recurs in Loos's obituary salute to Josef Veillich (1929), the stalwart craftsman who made most of the copies of eighteenth-century English chairs which he required for the interiors of his apartments and houses: 'In Frankfurt-am-Main the chairman of the local branch of the German *Werkbund* said I wasn't nationalistic enough. True, as they understand the term. In those circles my remark "Why do the Papuans have a culture and the Germans none?" is seen as anti-German, as a malicious wisecrack. That my remark comes from a bleeding German heart is something the German will never understand' (*OA* 188–89 n. 2).

When, if ever, does one hear Le Corbusier accused of racism when he borrows effectively from Loos fifteen years later – time that, if anything, should mean, in Loosian terms, knowing all

the better? His *Towards a New Architecture* (1923), the most influential architectural book of the twentieth century, is quite close to the spirit of Loos:

Civilizations advance. They pass through the age of the peasant, the soldier and the priest and attain what is rightly called culture. Culture is the flowering of the effort to select. Selection means rejection, pruning, cleansing; the clear and naked emergence of the Essential. (128) . . .

Art, in a highly cultivated country, finds its means of expression in pure art, a concentrated thing free from all utilitarian motives – painting, literature, music. (132) . . .

Decoration is of a sensorial and elementary order, as is colour, and is suited to simple races, peasants and savages. Harmony and proportion incite the intellectual faculties and arrest the man of culture. The peasant loves ornament and decorates his walls. The civilized man wears a well-cut suit and is the owner of easel pictures and books. Decoration is the essential overplus, the quantum of the peasant;

and proportion is the essential overplus, the
quantum of the cultivated man. (133)

Now this seems rather like a hasty digest of
'Ornament and Crime', complete with some
equivalent to the Loosian 'Beethoven' motif. The
appeal to 'harmony and proportion', however,
sounds much too French: Loos would never
speak so glibly of proportion (as cultural con-
servatives often do). More important here,
however, is something Le Corbusier actually
does not press: a sense, not so Loosian, that some-
how a house should be a 'a machine for living
in'[10] quite *instead of* a work of architectural art
in the conventional sense. One hastens to add
that looking like a sleekly beautiful machine is
for Corbusier a new way to look like architec-
tural art: the famous slogan is after all a figure
of speech, coming from a new aesthetic place
but aesthetic nevertheless. This was not exactly
Loos's way of stating the specially qualified non-
art case for architecture, but it is effectively
something he in some sense stated first.

That 'Ornament and Crime' always turns
out to be more challenging than one expects,

concerns the difficulty of breaking through conventional presuppositions about ornament as necessarily a refinement, to which even the Papuan-Maori analogue for the cultural 'stragglers' of modern times is subordinate. Loos finds it frustrating to deal with even certain made-to-order articles, such as gentlemen's shoes with 'wing-tips' perforated with curlicues – possibly the most classy English 'Papuan' fetish – to have them furnished plain, without ornamentation. The cobbler himself, however, proves sentimentally attached to the ornament he has, however absurdly, always been obliged to impose on the shoes he makes; and on the theoretical plane this must to some extent spoil a ready analogy with carpentry in building construction by which Loos wants to maintain that the craftsman knows better than the architect – certainly better than any architect who considers himself an artist and tries to impose his 'creativity' – how to make a plain good and almost by necessity beautiful thing.[11]

There does seem to be some confusion over the basically good idea of well made, simpler shoes which will not go quickly out of style, together

with higher pay and shorter hours for shoemakers, as a good thing all round. The confusion is not so much in the economics as in regard to the gratification versus alienation of the at least temporarily disappointed craftsman who always *thought* he liked punching the holes of the regularized wing-tip pattern as much as the peasant woman whom Loos otherwise permits to go on unembarrassedly enjoying her needlework because Beethoven is out of her cultural reach. Well, Loos could still look forward to public education bringing Beethoven to the artisan class as the peasantry disappeared; and it is no fault of him or of modernism that his essay becomes all the more challenging now that almost no Europeans or Americans except for cooks and some artists actually make anything anymore, while educational 'pragmatism' (US sense) discourages many youngsters from bothering about Beethoven, let alone his Viennese modernist successors.

BIBLIOGRAPHY

Coomaraswamy, Ananda K. 'Ornament.' *Art Bulletin* 21 (1939), 375–82.

Donne, J.B. 'Maori Heads and European Taste.' *RAIN* (Royal Anthropological Institute of Great Britain and Ireland), no. 11 (November-December 1975), 5–6.

Engels, Friedrich. *The Condition of the Working-Class in England in 1844,* trans. Florence Kelly Wischnewetsky. London: Allen and Unwin, 1892.

Finsch, Otto. 'Über Bekleidung, Schmuck, und Tätowirung der Papuas der Südküste von New-Guinea.' *Mitteilungen der Anthropologischen Gesellschaft in Wien* 15 (1885), 12–33.

Greenough, Horatio. *Form and Function: Remarks on Art,* ed. Harold A. Small. Berkeley: University of California Press, 1947.

Grosse, Ernst. *The Beginnings of Art.* Anthropological Series. New York: Appleton, 1900.

Hamsun, Knut. *The Cultural Life of Modern America* (1889), trans. and ed. Barbara Morgan

Morgridge. Cambridge, Mass.: Harvard University Press, 1969.

Heine-Geldern, Robert. 'L'Art prébouddhique de la Chine et de l'Asie du Sud et son Influence en Océanie.' *Revue des Arts Asiatique; Annales de la Musée de Guimet* 11 (1937). 177–206.

Janik, Alan. 'Paul Engelmann's Role in Wittgenstein's Philosophical Development.' In Judith Bakacsy, Anders V. Munch, and Anne Louise Sommer, eds., *Architecture: Language, Critique.* Studien zur Österreichischen Philosophie. Amsterdam and Atlanta: Rodopi, 2000. Pp. 40–58.

——. 'Weininger and the Science of Sex: Prolegomena to Any Future Study.' In Robert P. Pynsent, ed., *Decadence and Innovation: Austro-Hungarian Life and Art at the Turn of the Century.* London: Weidenfeld and Nicolson, 1989. Pp. 24–32.

Kandinsky, Wassily. *On the Spiritual in Art and Painting in Particular,* 2nd edn, trans. and ed. Kenneth C. Lindsay and Peter Vergo. In their edition Kandinsky, *Complete Writings on Art,* 2 vols. Boston: Hall, 1982. Vol. I (1901–21), 114–219.

Kant, Immanuel. *Prolegomena to Any Future Meta-physics That Will Be Able to Come Forward as a Science,* trans. Paul Carus, rev. James W. Ellington. Indianapolis: Hackett, 1977.

——. *Werke,* ed. Ernst Cassirer et al. 11 vols. Berlin: Cassirer, 1912–23. Vol. 4: *Schriften 1783–1788,* ed. Arthur Buchenau and Ernst Cassirer.

Le Corbusier. *Towards a New Architecture,* trans. Frederick Etchells (1927). London: Architectural Press, 1946, repr. 1965.

Lombroso, Cesare. *Criminal Man,* trans. Mary Gibson and Nicole Hahn Rafter. Durham, N.C.: Duke University Press, 2006. Variorum edition.

Lubbock, John. *The Origin of Civilization and the Primitive Condition of Man* (1870), ed. Peter Rivière. Chicago: University of Chicago Press, 1978.

Masheck, Joseph. 'Raw Art: Primitive "Authenticity" and German Expressionism' (1982). In his *Modernities: Art Matters in the Present.* University Park: Pennsylvania State University Press, 1993. Pp. 155–92.

——. 'The Vital Skin: Riegl, the Maori, and Loos.' In Richard Woodfield, ed., *Framing Formalism:*

Riegl's Work. Critical Voices in Art, Theory and Culture. Amsterdam: G+B Arts International, 2001. Pp.151–82.

Muthesius, Hermann. *Style-Architecture and Building Art: Transformations of Architecture in the Nineteenth Century and Its Present Condition*, trans. Sanford Anderson. Texts & Documents. Santa Monica, Calif.: Getty Center for the History of Art and the Humanities, 1994.

Nietzsche, Friedrich. *Thoughts Out of Season,* Part II, trans. Adrian Collins. In the Complete Works, ed. Oscar Levy. Edinburgh and London: Foulis, 1909.

Robinson, Paul A. *The Freudian Left: Wilhelm Reich, Geza Rohem, Herbert Marcuse*. New York: Harper and Row, 1969.

Stewart, Janet. *Fashioning Vienna: Adolf Loos's Cultural Criticism.* London and New York: Routledge, 2000.

Symonds, Arthur. 'The Decay of Craftsmanship in England.' In his *Studies in Seven Arts.* London: Constable; New York: Dutton, 1906.

Vergo, Peter. *Art in Vienna 1898–1918: Klimt, Kokoschka, Schiele and Their Contemporaries,* 3rd edn London: Phaidon, 1993.

Vico, Giambattista. *The New Science,* 3rd edn, trans. Thomas Goddard Bergin and Max Harold Fisch. Ithaca, N.Y.: Cornell University Press, 1984.

Whistler, James Abbott McNeill. *The Gentle Art of Making Enemies,* 2nd edn. New York: Putnam, 1982; repr. New York: Dover. 1967.

NOTES

1 *Privy Councillor Arthur von Scala*: Arthur von Scala (1845–1909), the director of Vienna's Oriental Museum, took over the Museum of Art and Industry, which he remodelled along the lines of the English Arts and Crafts movement.

2 *Eitelberger*: Rudolf Eitelberger von Edeleberg (1817–85), art historian and reputed founder of the Vienna School of Art History.

3 *Meister Diefenbach*: Karl Wilhelm Diefenbach (1851–1913), German painter.

4 *Rigo*: Rigó Jancsi (1858–1927), a famous Hungarian Romany violinist who has a type of chocolate cake named after him.

5 *Holy Clauren*: Pseudonym of Karl Heun (1771–1854), author of sentimental tales that appealed to the German bourgeoisie.

6 *Lenbach*: Franz von Lenbach (1836–1904), a prominent German portrait-painter.

7 *Sacher-Masoch, Catulle Mendès and Armand Sylvestre*: Leopold von Sacher-Masoch (1836–95), an

329

Austrian author best known for the novella *Venus in Furs* (1870). He gave his name to the term *masochism*. Catulle Mendès (1841–1909), a French poet and writer, author of the erotic novel *Roman d'une nuit*, for which he was imprisoned. Paul-Armand Silvestre (1837–1901), a French poet, author of erotic verse, notably *Les Sept Péchés capitaux. La luxure* (1901).

8 *le cul de Paris*: A type of bustle popular in the 1870s.

9 *Peter Altenberg*: Peter Altenberg (1859–1919), Austrian writer and bon viveur, noted for his psychological studies of Viennese women and girls.

10 *The Barrisons*: The Barrison Sisters, a risqué vaudeville act from Copenhagen who toured Europe and the United States in the 1890s. Known as 'the baddest girls in the world'.

11 *Hic Rhodus, hic salta*: Literally 'This is Rhodes, jump here!', from the Latin version of Aesop's fable 'The Boastful Athlete'. Meaning: 'Prove what you can do, right now.'

12 *a meaning preserved in the Germanic languages even today*: The German word *Decke* means both 'ceiling' and 'blanket'.

13 *Schmidt*: Friedrich von Schmidt (1825–91), architect, designer of Vienna City Hall.

14 *Hansen*: Theophil Hansen (1813–91), architect, one of the designers of Vienna's Ringstrasse.

15 *Ferstel*: Heinrich von Ferstel (1828–83), architect, major contributor to the design of late nineteenth-century Vienna.

16 *chamotte*: A hard ceramic material, also known as grog and firesand.

17 *Philippopel*: A small town in Bulgaria.

18 *Otto Eckmann*: Otto Eckmann (1865–1902), German painter and designer, of the 'floral' Jugendstil school.

19 *Van de Velde*: Willem van de Velde (1633–1707), Dutch painter of seascapes.

20 *Olbrich*: Joseph Maria Olbrich (1867–1908), Austrian architect.

21 *Copenhagen cat*: A porcelain figure of a cat made by the Danish Royal Porcelain Manufactory in the 1890s.

22 *Habsburgwarte*: A watchtower built on Hermannskogel, a hill in the Vienna Woods, in 1888–9.

23 *the Hussars' Temple*: A neoclassical temple, also in the Vienna Woods, built in 1810.

24 *revenue houses*: *Zinshaus*, the nineteenth-century precursor of the tenement block.

25 *Lainz*: A part of western Vienna.

EPILOGUE
BY JOSEPH MASHECK

Abbreviations

AAL *The Architecture of Adolf Loos: An Arts Council Exhibition*, ed. Yehuda Safran and Wilfried Wang (1985), 2nd edn (London: Arts Council of Great Britain, 1987). Especially Loos's 'Architecture' as translated by Wang, pp. 104–9.

OA Adolf Loos, *On Architecture*, ed. Adolf and Daniel Opel, trans. Michael Mitchell (Riverside, Calif.: Ariadne, 2002).

OC Adolf Loos, *Ornament and Crime*, ed. Adolf Opel, trans. Michael Mitchell (Riverside, Calif.: Ariadne, 1998).

T Adolf Loos, *Trotzdem*; 1900–1930, ed. Adolf Opel (Vienna: Prachner, 1988). Especially 'Architektur,' pp. 90–104.

1 The dates conventionally given to Loos's essays 'Ornament and Crime' and 'Architecture' – '1908 and 1910, respectively' – prove questionable. In re-dating these key texts I follow Christopher Long in favouring 1909 for the former (as it was written out in 1909 and delivered as a lecture in the following January), while retaining the usual date for the latter as 1910, notwithstanding its expansion in 1911: 'The Origins and Context of Adolf Loos's "Ornament and Crime",' *Journal of the Society of Architectural Historians* 68, no. 2 (June 2009), 200–23.

2 When Loos addressed the subject, the great sociologist Durkheim, aware of Lombroso, was at work on his classic study of the sociology of religion, which sees tattoo as removed from religion (even in archaic culture it is not innately totemic-religious despite sixth-century testimony of early Christians having 'the name of Christ or the sign of the cross' inscribed on their skin), and clearly a matter of social position. Loos's sense of tattoo as practically identifiable with a lumpenproletarian underclass *ressentiment* is effectively seconded by Durkheim's speaking freely of tattoo as characteristic of 'men

of an inferior culture . . . shar[ing] a common life'
as 'led, almost instinctively', to such practices for
solidarity. Émile Durkheim, *The Elementary
Forms of Religious Life* (1912), trans. Karen
E. Fields (New York: Free Press, 1995), 116, 233.

3 The problem, here, of recommending the aloof
cultural non-interference of the 'aristocrat', vis-
à-vis his or her cultural inferiors (even allowing
for the idealistic implication that anybody who
cares might ascend to such taste), is similarly
relative, if gentler: Loos is advocating what now
seems like liberal toleration over and against any
more presumptuous, pseudo-progressive cul-
tural cleansing of the lower echelons 'for their
own good'. Besides, surviving naïve folk crafts
may not only be innocent of atavism but also
better than the alienated industrial rubbish
likely to replace them.

4 Two of the founders of abstract painting, Wass-
ily Kandinsky and Piet Mondrian, use the same
memorable figure within a few years of 'Orna-
ment and Crime'. After beginning *Concerning
the Spiritual in Art and Painting in Particular* (1911)
with the motif of art of a child born into histor-
ical time, and a developmental trope of the

ancient Greeks in juxtaposition with an ape pretending to read a book, Kandinsky, who had Arnold Schoenberg as a friend in common with Loos, declares that contemporary materialism 'create[s] a sharp distinction between our souls and those of the "primitives"', and proceeds to invoke Beethoven repeatedly – as with Loos, as a great artist more advanced than the world at large. Interested from early on in folk ornament, Kandinsky writes that ornamentation 'is . . . either no longer comprehensible to us (ancient ornament) or else is only an illogical confusion . . . a . . . world in which, so to speak, grown men and embryos are treated in the same way and play the same role in society . . .'; he also mentions the sexual origins of the dance as still resonating in folk-dancing (Kandinsky 198, 197, 199). Even the Calvinist Mondrian occasionally speculated on a horizontal natural (female) element and a vertical spiritual (male) element'. This sort of thing is often enough explained away in both artists as theosophical; but Kandinsky was living in Munich when Loos gave 'Ornament and Crime' as a lecture there (Long 213–14). Mondrian was living in Paris in June

1913, when the first published version in any language of Loos's rather striking text appeared in *Cahiers d'aujourd'hui*, but that text shyly lacks Loos's sexual motif. The present author discounts this sex topos as well as Theosophy as ultimately important to Mondrian in his *Classic Mondrian in Neo-Calvinist View*, The Watson Gordon Lecture 2017 (Edinburgh: National Galleries of Scotland, 2018), 41, n. 1, with more discussion of the topos in his 'A Christian Mondrian', *The Bavinck Review* (online) 6 (2015), 37–72.

5 Walher Benjamin was obviously remembering 'Ornament and Crime' when, in the *Zeitschrift für Sozialforschung* for 1939–40, he published excerpts from Jochmann's 'Regression of Poetry', e.g. 'The first care the savage takes of his body consists in its superstitious embellishment; he thinks he is adorning himself by torturing himself, beautifying himself by self-mutilation ... [He] distorts and poisons his divine spiritual image ... long before he knows how to protect and preserve that image.' In Benjamin, *Selected Writings*, ed. Marcus Bullock and Michael W. Jennings, 4 vols (Cambridge, Mass.: Harvard University Press, 1996–2003); vol. 4, *1938–1940*,

trans. Edmund Jephcott et al., ed. Howard Eiland and Michael W. Jennings, 370–80, here p. 364. While one understands Benjamin's wish to find this 'a new positive concept of barbarism' (p. 732) for purposes of the kind of fresh start initiated by Loos's clean sweep, there would seem to be confusion between the notion of a golden age in the past and that of a golden age to come, it being impossible to confuse Loos's conception of a high-cultural fresh start with even a metaphoric primitivism of given basics or elementals: Loosian elementals definitely had to be *worked up to*. Thanks to Charles W. Haxthausen for calling my attention to this text.

6 Cf. John Lubbock, *Pre-Historic Times; As Illustrated by Ancient Remains and the Manners and Customs of Modern Savages*, 2nd edn (London: Williams and Norgate, 1869), 3: 'even the rudest savages ... are known to be very fond of personal decoration'. On Lubbock's influence on Nietzsche: David S. Thatcher, 'Nietzsche's Debt to Lubbock', *Journal of the History of Ideas* 44, no. 2 (April–June 1983), 293–309.

7 Cf. Masheck, 'Vital Skin'. In 1899 Thorsten Veblen held a less favourable view of the

admittedly 'well-carved handles of the ceremo-
nial adzes of several Polynesian islands': though
'undeniably beautiful' in terms of 'pleasing com-
position of form, lines and colour,' and formid-
able as to 'skill and ingenuity in design and
construction', these were 'manifestly ill suited to
serve any other economic purpose' than social
display, so much 'wasted effort'. But Veblen
shows a Calvinist prejudice against something
ceremonial as useless and wasteful, and possibly
the nineteenth-century naturalistic prejudice that
only representation really counts as art ('elements
that would bear scrutiny as expressions of
beauty'); *The Theory of the Leisure Class* (New
York: New American Library, 1953), 110.

8 The bicycle and the steam-engine, and for that
matter the Greek tripod which the bicycle resem-
bles as a complex of tension and compression,
leave, as it were, no room for ornament, showing
their orderliness fully and self-evidently. That in
their linguistic way, precisely as self-evident
manifestations of order, the Greek 'orders' of
columns can be said to do the same allows them,
when properly deployed, not necessarily to con-
taminate or disqualify the blankness Loos seeks.

338

He speaks rather indiscriminately of ornament and what could be distinguished as 'decoration'; this is a complicated subject, partly because, when such a distinction is in effect, 'decorum' may concern *ornament*. It helps to understand the importance of order to ornament, on which see Jacques Soulillou's Loos-aware 'Ornament and Order', trans. Mark Heffernan, in Bernie Miller and Melony Ward's anthology *Crime and Ornament: The Arts and Popular Culture in the Shadow of Adolf Loos* (Toronto: XYZ Books, 2002), 86–99.

9 Hence being an artist can hardly, in and of itself, be a bad thing.

10 On this figure, I have written 'Textual Life of the Living-Machine', in Joseph Masheck, *Building-Art: Modern Architecture Under Cultural Construction* (Cambridge: Cambridge University Press, 1993), 77–94; with notes, 252–9.

11 Was Loos, with his modicum of Benedictine education, aware of significant late-antique Christian precedents for his imagery in this vital point of ethico-aesthetic critique? In early modern Viennese culture Augustine was of conspicuous interest to Riegl and to Wittgenstein.

John Chrysostom, already briefly noted in this essay, says that the rich man, having no worthy craft, such as metalworking, shipbuilding, weaving, or house-building, should cultivate 'a better art than all those,' by 'learn[ing] . . . to use his wealth aright, and to pity the poor,' i.e. charity, which 'far excels' even arts as necessary in the here and now as 'house-building'. Not even painting, let alone embroidery, should count as art, 'for they do but throw [people] into useless expense', whereas 'the arts ought to be concerned with things necessary and important to our life'. Like Loos on more than men's shoes, Chrysostom observes: 'the sandal-makers . . . should have great retrenchments made in their art. For most things in it they have carried to vulgar ostentation, having corrupted its necessary use, and mixed with an honest art an evil craft; which has been the case with the art of building also. But even as to this, so long as it builds houses and not theatres, and labors upon things necessary, and not superfluous, I give the name of an art,' whereas ornament strikes him as effeminate, and markedly exotic ornamentation stems from tribal culture. Apropos of men's

shoes in particular there is found a most Loosian cadenza: 'for first a ship is built, then rowers are mustered, and a man for the prow, and a helmsman, and a sail is spread, and an ocean traversed, and, leaving wife and children and country, the merchant commits his very life to the waves, and comes to the land of the barbarians, and undergoes innumerable dangers for these threads, that after it all thou mayest take them, and sew them onto thy shoes, and ornament the leather. And what can be done worse than this folly?' Making matters worse, all this amounts to so much social sin, for it is instead of helping the Christ to be found in the poor: for 'how many thunderbolts must ye not deserve, overlooking Him in want of necessary food, and adorning these pieces of leather with so much diligence?' There is even a Rieglesque note where the motif of the tendril again, in Riegl's *Problems of Style* is devoted to the evolution of tendril ornament – as in the wing-tip shoe ornament criticized in 'Ornament and Crime' – is specifically pointed up in association with the wasteful and self-indulgent luxury of ornamenting clothing and shoes (St John Chrysostom, 'Homily XLIX on Matthew',

in *Early Christian Fathers: Nicene and Post-Nicene,* ser. I, vol. X, sects 4-7 [http://www.ccel.org/ fathers2/NPNF1-10-55.htm#P4738_1492441]).

More likely encountered would have been the *Confessions* of Augustine, Book X, which addresses more broadly the problem of the visual allure of exaggerated sensuous attractions, including superadded ornamentation. 'To entrap the eyes men have made innumerable additions', as Augustine calls them, 'to the various arts and crafts in clothing, shoes, vessels, and manufactures of this nature, pictures, images of various kinds, and things which go far beyond necessary and moderate requirements . . .' These errors of excess are charged to some spiritual failing on the artist's part, but 'higher' beauty is unscathed by private ethical disqualification; even so, when 'the artists and connoisseurs of external beauty draw their criterion of judgement', they miss 'a principle for the right use of beautiful things' which 'is there but they do not see it, namely that they should not go to excess, but reserve their strength for holy things "and not dissipate it in delights"', such as superfluous ornamentation, 'that produce mental fatigue' (X.xxxiv.53; St

Augustine of Hippo, *Confessions*, trans. and ed. Henry Chadwick (Oxford World Classics. Oxford: Oxford University Press, 1992), 210). These patristic sources are part of the cultural background to Loos's ethico-aesthetic critique of ornamental superfluity, with its preferential option for simplicity.

In the High Middle Ages calls to simplicity are found in thinkers as different as Peter Abelard and Bernard of Clairvaux: e.g. the former's appeal to nature against cosmetic luxury in his letters to Heloise and a famous letter of the latter against luxurious and distracting church decorations. Thomas Aquinas speaks several times against superadded ornamentation in the *Summa Theologica*.